# Conestogo and Bloomingdale Ontario and Area in Colour Photos, Saving Our History One Photo at a Time

Photography
by Barbara Raué
2015

Series Name:
Cruising Ontario

Book 111: Conestogo, Bloomingdale

Cover photo: West Montrose Covered Bridge

# Series Name: Cruising Ontario
# Saving Our History One Photo at a Time
# in colour photos

Book 33: Southampton
Book 34: Jarvis
Book 35: Hagersville
Book 36: Caledonia
Book 37: Simcoe
Book 38-41: Cambridge
Book 42-43: Kitchener
Book 46: Shelburne
Book 47: Alton, Mono
Book 48: London Colour
Book 49: St. Thomas
Book 50-52: Orangeville
Book 53-55: Dundas
Book 56: Stratford
Book 57: Hanover
Book 58-59: New Hamburg
Book 60: Waterdown
Book 61: Burlington
Book 62: Stoney Creek
Book 63: Seaforth
Book 64: Aberfoyle, Morriston and Rockton
Book 65: Eden Mills
Book 66: Ancaster and Mount Hope
Book 67: Jarvis, Pt. Dover
Book 68-69: Fergus, Elora
Book 70-71: Elmira
Book 72: St. Jacobs, St. Clements, Heidelberg, Crosshill, Bamberg

Book 73: Linwood, Macton
Book 74: Wellesley
Book 75: Listowel
Book 76: Palmerston
Book 77: Dorchester to Aylmer
Book 78-79: Aylmer
Book 80: Drayton & Area
Book 81: Tillsonburg
Book 82: Arthur
Book 83: Rockwood
Book 84: Acton
Book 85-86: Guelph
Book 87-91: Hamilton
Book 92-93: Owen Sound
Book 94: Oakville
Book 95: Brantford
Book 96: Mount Forest
Book 97: Orillia
Book 98: Ayr
Book 99-101: Peterborough
Book 102-104: Niagara on Lake
Book 105: Harriston, Clifford
Book 106: Neustadt
Book 107-108: Port Elgin
Book 109: Wingham, Blyth
Book 110: Lucknow, Mitchell
Book 111: Conestogo, Bloomingdale

# Other Books by Barbara Raue

Coins of Gold

Arrows, Indians and Love

The Life and Times of Barbara
Volume 1: Inventions That Have Enhanced My Life
Volume 2: Entertainment That I Have Enjoyed
Volume 3: East Coast Trips
Volume 4: Olympics Have Always Intrigued Me
Volume 5: Wonders of the World
Volume 6: Caribbean Cruises We Have Enjoyed
Volume 7: Animals
Volume 8: Storms and Other Major Disasters in My Lifetime
Volume 9: Wars, Terrorist Attacks and Major Disasters

The Cromwell Family Book

Laura Secord Discovered

Daddy Where Are You?

Visit Barbara's website to view all of her books
http://barbararaue.ca

The Township of Woolwich is located to the north and east of the City of Waterloo. The Township of Waterloo was established in its present configuration by the Regional Municipality of Waterloo Act 1972, which created a regional government structure and established limits of the local municipalities in Waterloo area effective January 1, 1973.

Woolwich Township began to be settled in the late 1700s, with William Wallace being one of the first settlers arriving in 1798. The township was named in honour of a government surveyor.

Woolwich consists of an extensive rural area along with residential communities and industrial/commercial areas. The residential communities include: Elmira, St. Jacobs, Breslau, Conestogo, Heidelberg, Maryhill, Bloomingdale, West Montrose, Foradale, Winterbourne, Crowsfoot Corners, Mundil, Weber, Shanz Station, Martin Grove Village and Eldale.

## Conestogo

Connestogo is located at the junction of the Grand and Conestogo Rivers in the township of Woolwich in Waterloo Region. The area was first settled in the 1820s by predominantly Mennonite settlers who had emigrated from Pennsylvania. They were followed by people of German and British background.

The first mill in Woolwich Township was built in Conestogo in 1844 by David Musselman. Known earlier as Musselman's Mills, the settlement was renamed Conestogo in 1852. The name originated from the town and river of Conestoga in Lancaster County, Pennsylvania.

By the middle of the 19th century, Conestogo was a thriving community of about 300 people. It boasted a number of businesses, including a foundry, flour mill, sawmill, furniture factory, paint factory, flax mill, distillery, four hotels, three blacksmiths, two wagon makers and a cooperage, among others. Two local brickyards produced the bricks of which many Conestogo buildings were constructed. The slow pace of Conestogo's development after the 1870s resulted in much of the architectural heritage being well preserved.

The feed mill closed its feed production operation in 2008. New retail stores such as the Conestogo Mercantile and Baby Charlotte do business alongside the antique store and the well-known restaurant and dinner theatre, the Blackforest Inn.

## Bloomingdale

The community was named in 1861, likely by a settler from Pennsylvania after Bloomingdale in Luzerne County, Pennsylvania.

## West Montrose

West Montrose straddles the Grand River, one of Canada's historic rivers. West Montrose was settled in 1806 by Scots from Montrose, Scotland. The village was an industrious community with a woolen mill, saw mill, lime kiln, feed mill, two blacksmith shops, shoemaker and several stores. In 1902 the railway built tracks and a station north of the village to transport goods and livestock. Today the peaceful village is surrounded by Mennonite farms and most of the people living in the community commute to larger centers to work. The more recent outlying town is home to many large residences.

The West Montrose covered bridge was constructed in 1881 by John and Benjamin Bear and is best known for being the last remaining historical covered bridge in Ontario. These bridges were known colloquially as 'kissing bridges' since couples would be out of sight as they passed through the bridge. While the original bridge was constructed entirely of wood, in a series of repairs and restorations the bridge uses a combination of materials but retains its original form. The Region of Waterloo, in collaboration with the Township of Woolwich and local residents, is committed to maintaining the West Montrose Covered Bridge as a viable open bridge with the appropriate limitations to ensure that the heritage integrity of the structure is conserved.

## Table of Contents

| | |
|---|---|
| Conestogo | Page 7 |
| Bloomingdale | Page 28 |
| West Montrose | Page 35 |
| Ariss | Page 45 |
| Architectural Terms | Page 48 |
| Building Styles | Page 51 |

# Conestogo

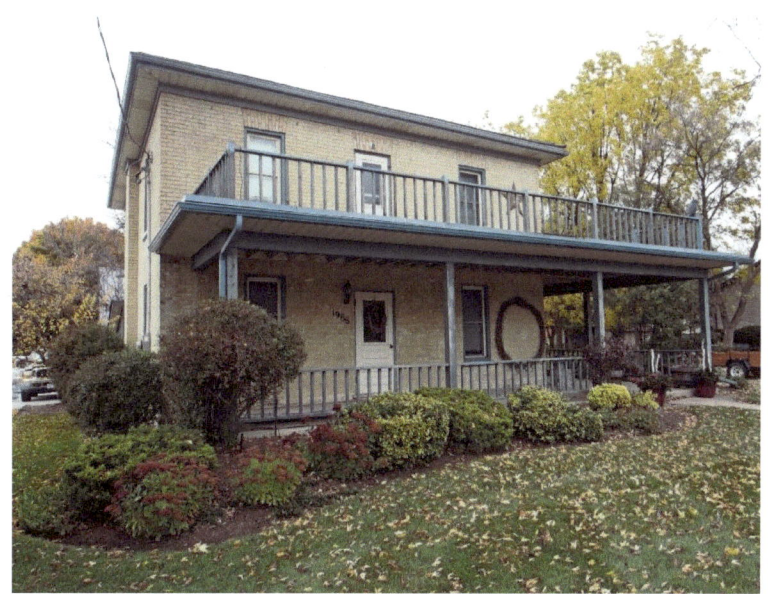

#1966

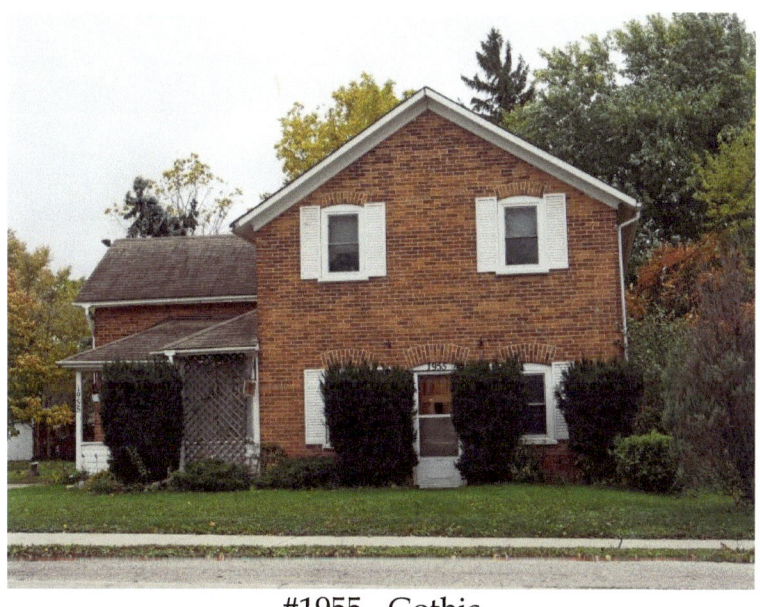

#1955 - Gothic

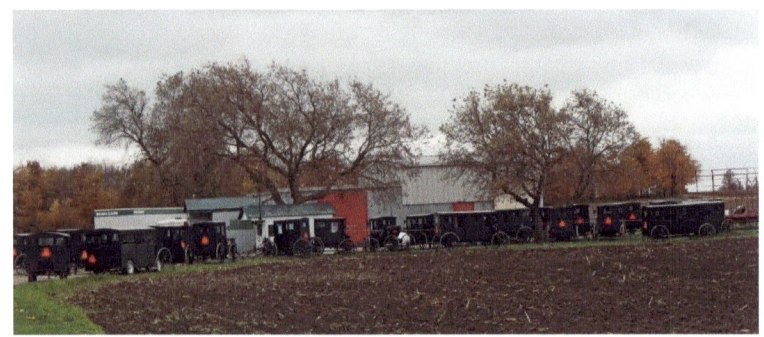

Mennonite buggies

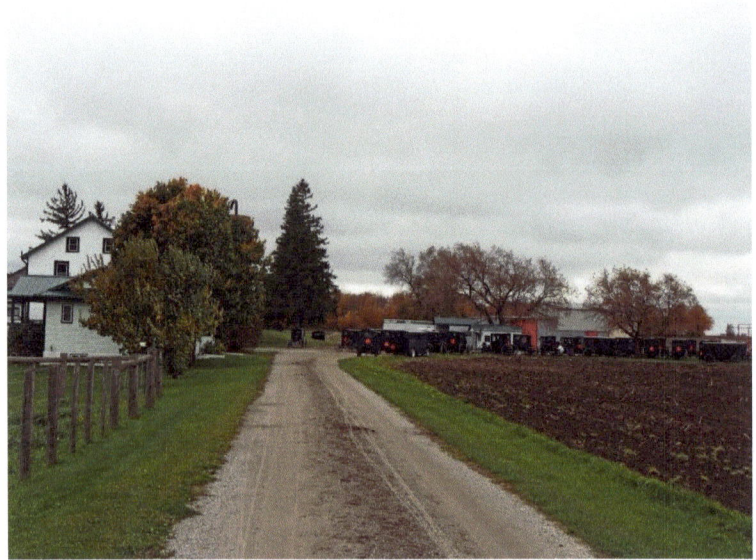

Mennonite farm

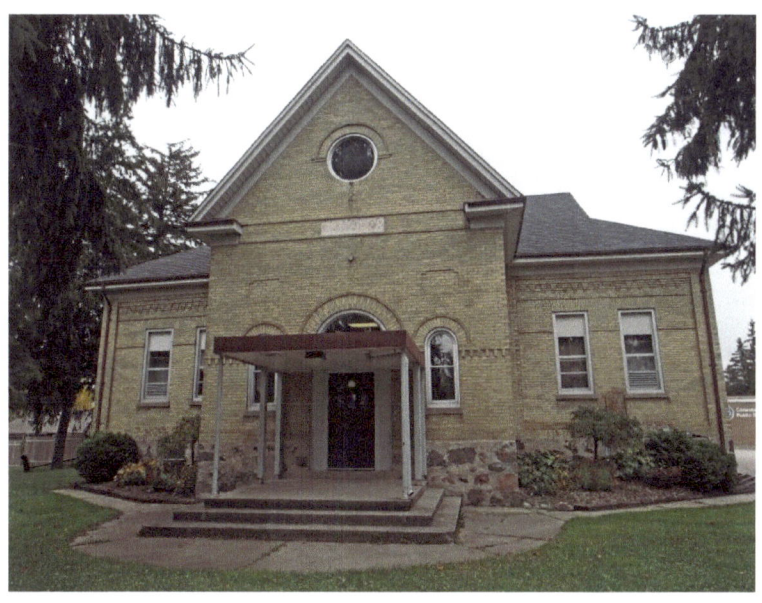

Conestogo Public School – Gothic, Romanesque-style central window arches, bevelled dentil moulding on side sections

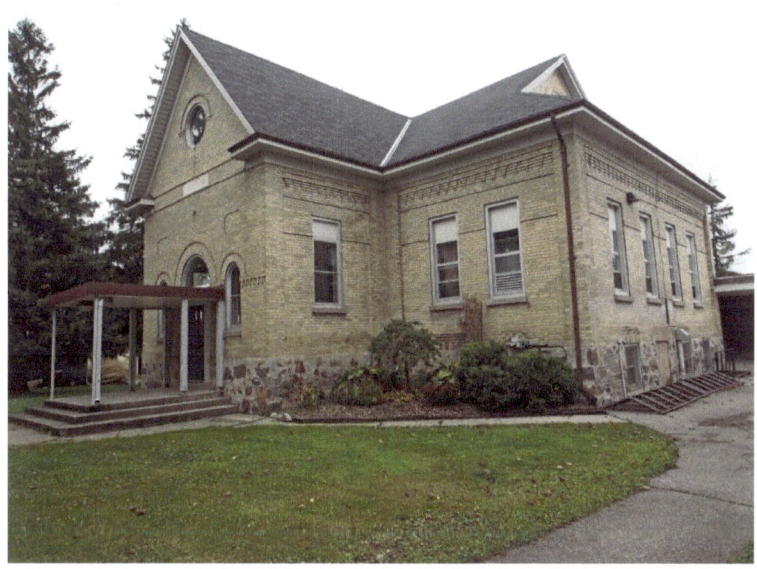

Cobblestone basement walls

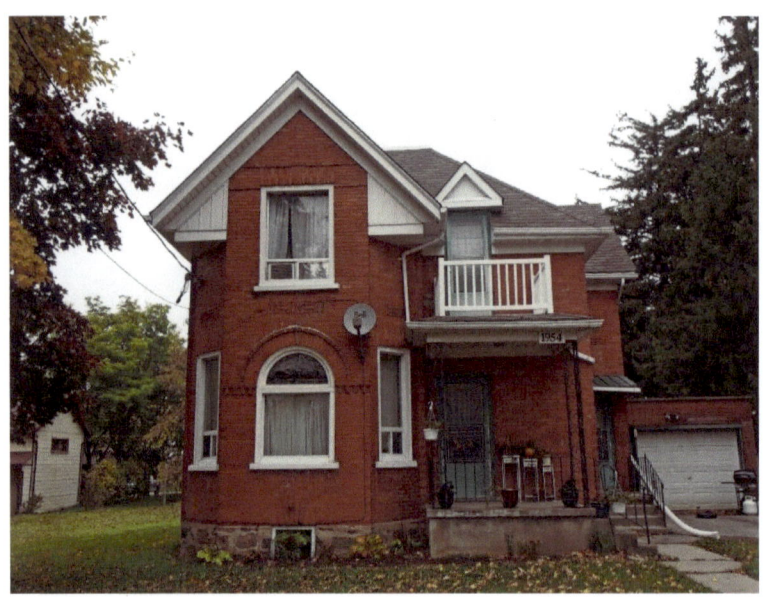

#1954 – two-storey tower-like bay, 2nd floor balcony

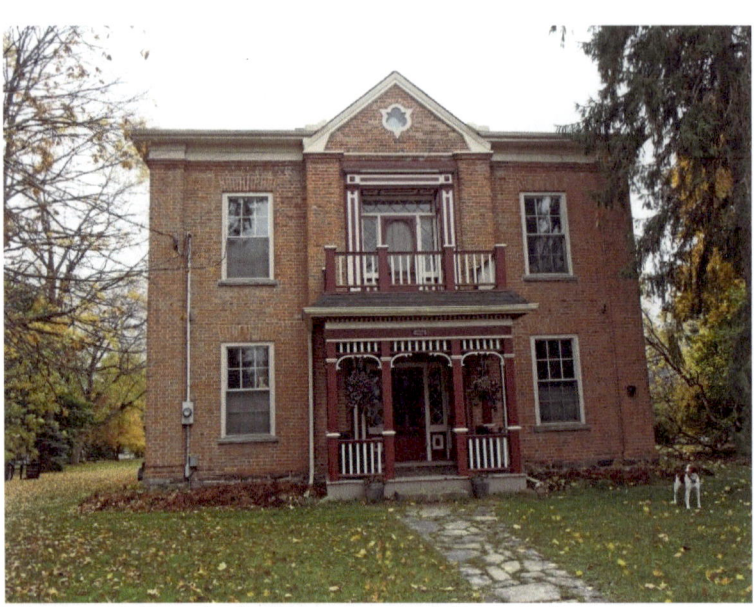

1939 Sawmill Road - Italianate – 2nd floor balcony, both 1st and 2nd floor entrances

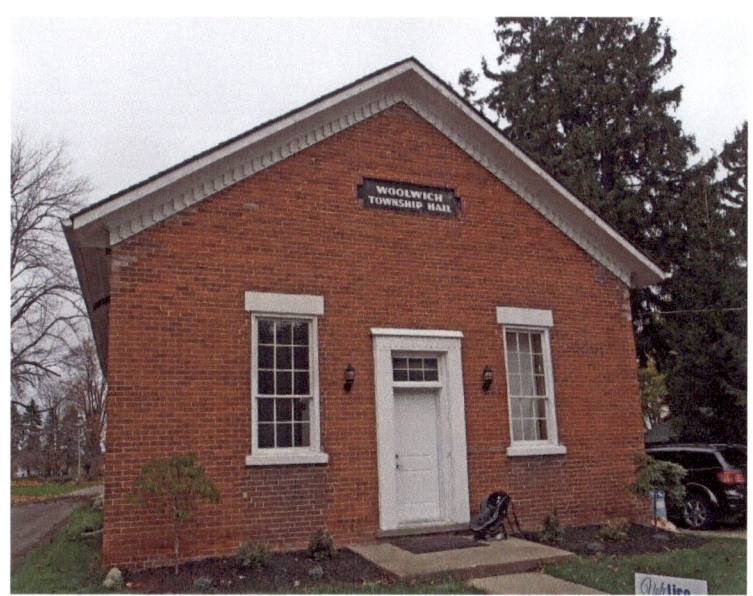

Woolwich Township Hall

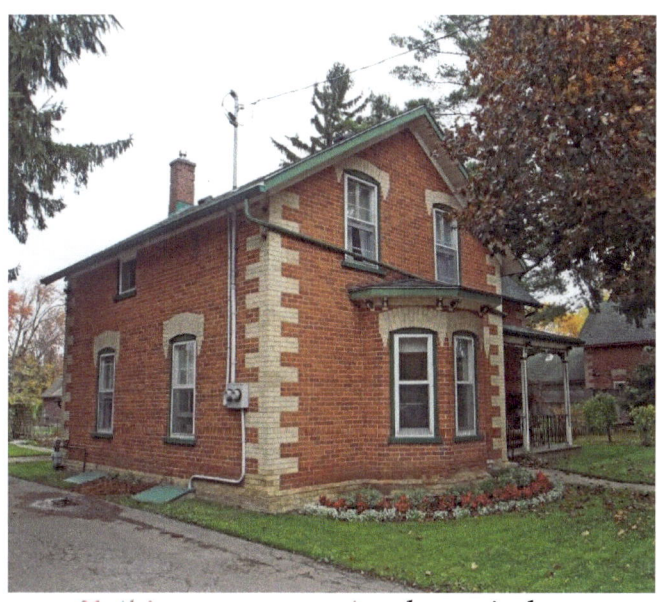

Gothic – corner quoins, bay window,
buff coloured window voussoirs, bay window

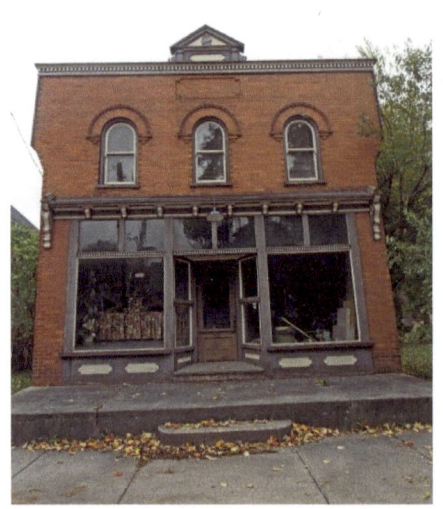

1915 Sawmill Road – Romanesque style window arches, dentil moulding, cornice brackets

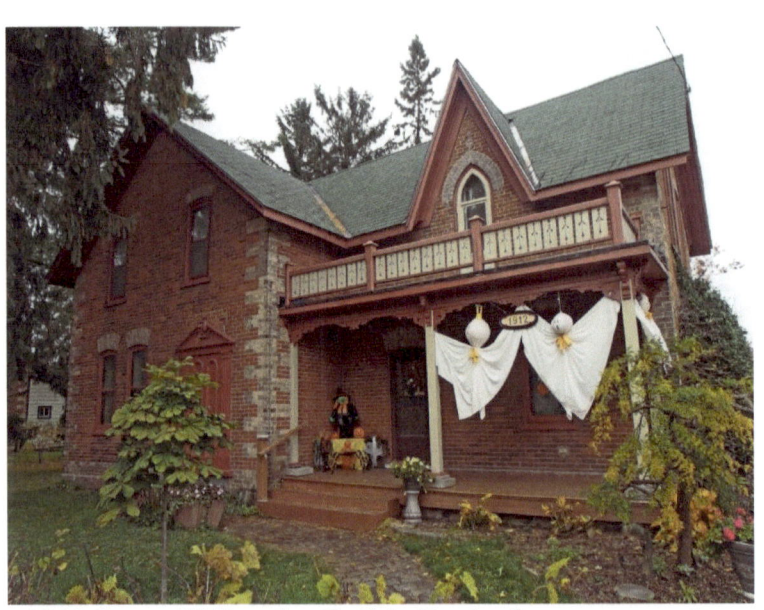

1912 Sawmill Road – Gothic Revival, corner quoins, 2nd floor balcony

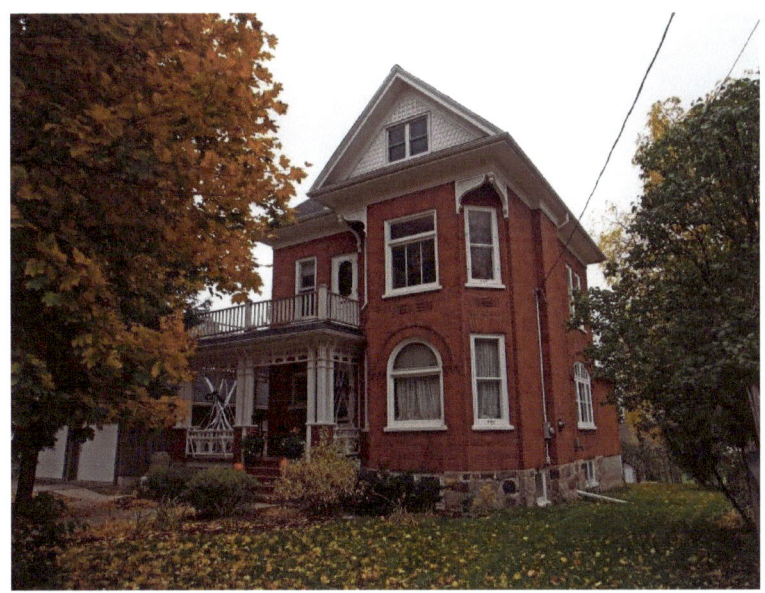

Edwardian – 2 storey tower-like bay, fretwork, Romanesque style window arches, 2nd floor balcony, cobblestone basement

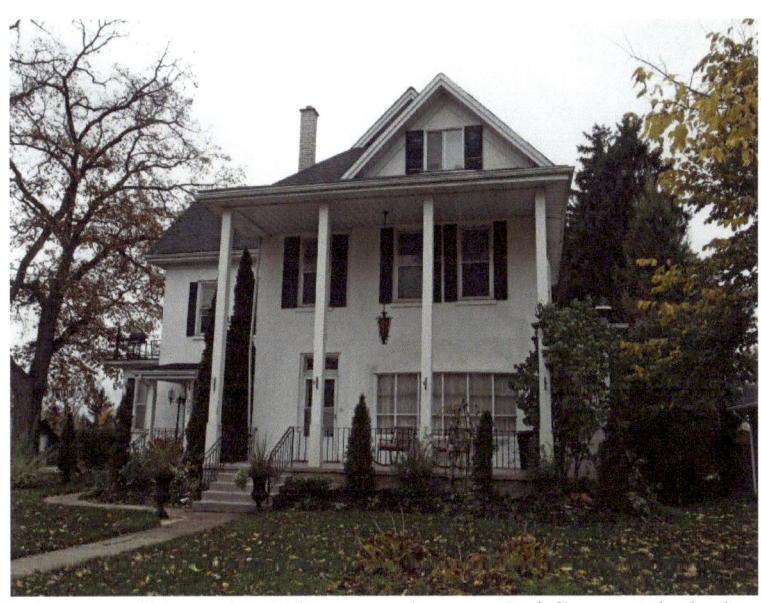

1907 Sawmill Road – 2½ storey home, 2nd floor side balcony

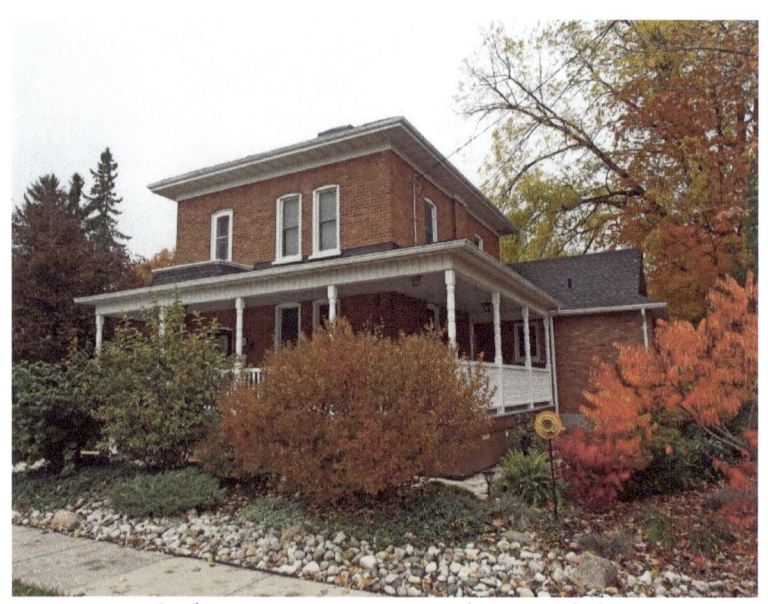

Italianate, wraparound verandah

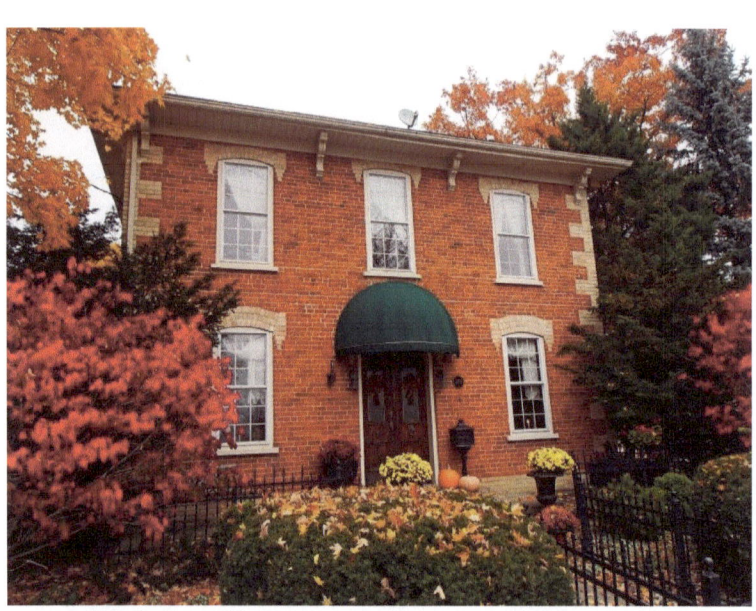

1900 Sawmill Road - Italianate, corner quoins, single cornice brackets

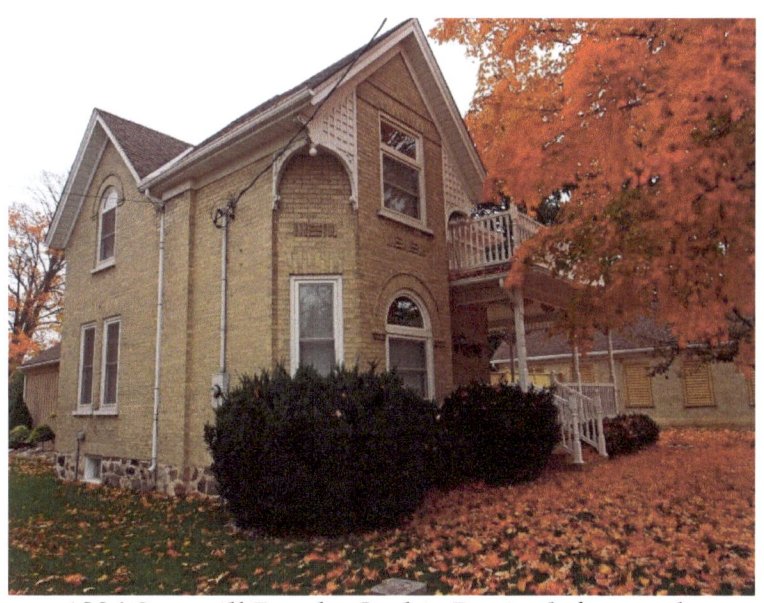

1896 Sawmill Road - Gothic Revival, fretwork, 2nd floor balcony, Romanesque style window arches

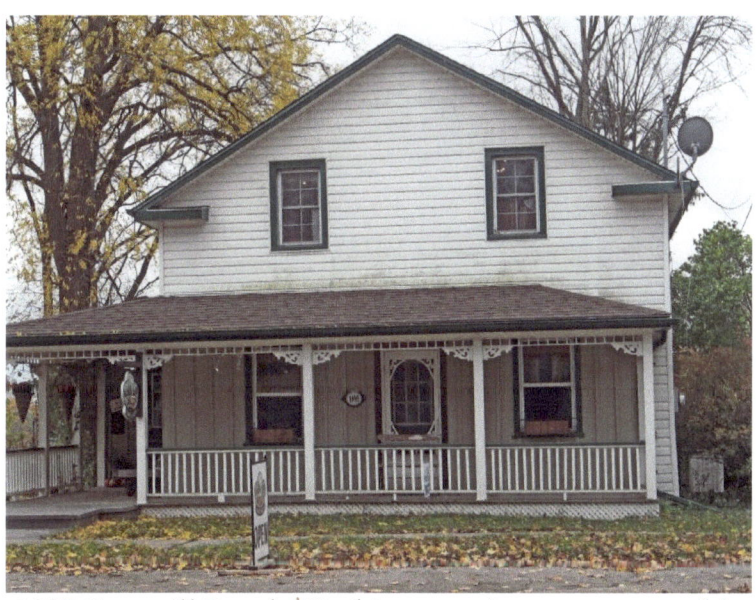

1895 Sawmill Road - Gothic – cornice return on gable

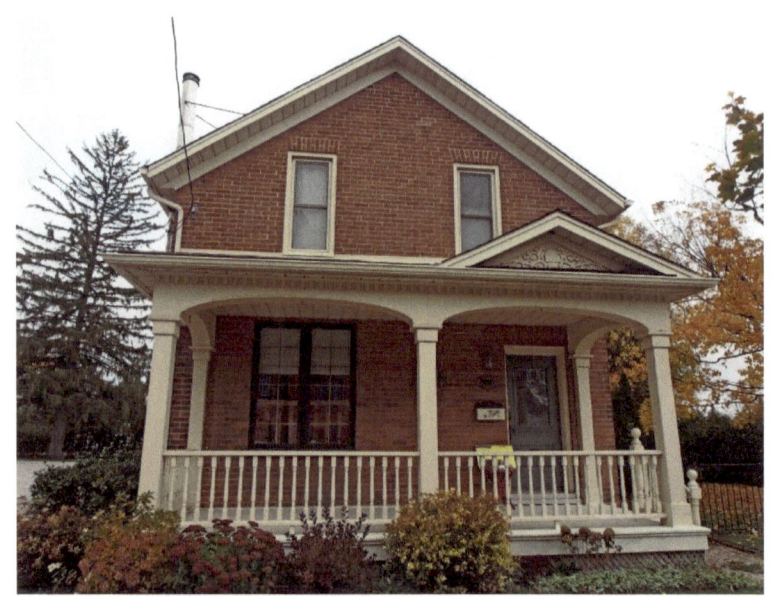

1880 Sawmill Road – Gothic Revival,
pediment with decorated tympanum

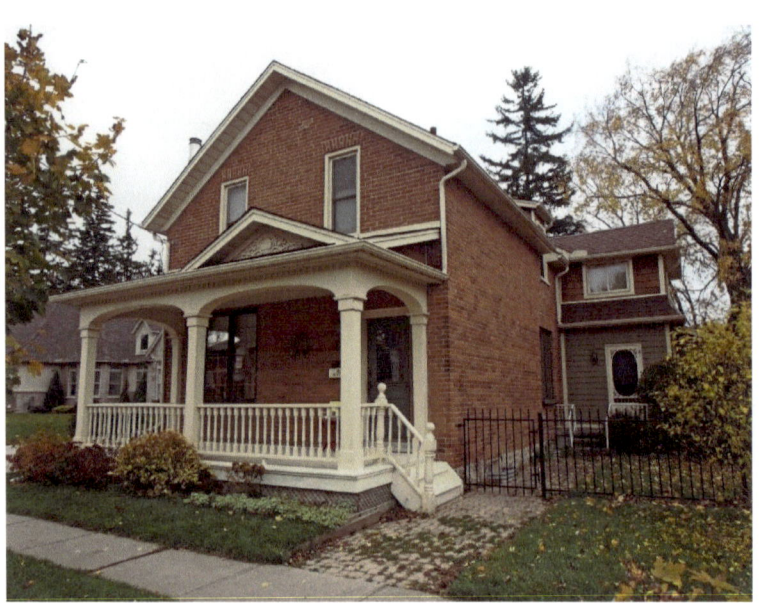

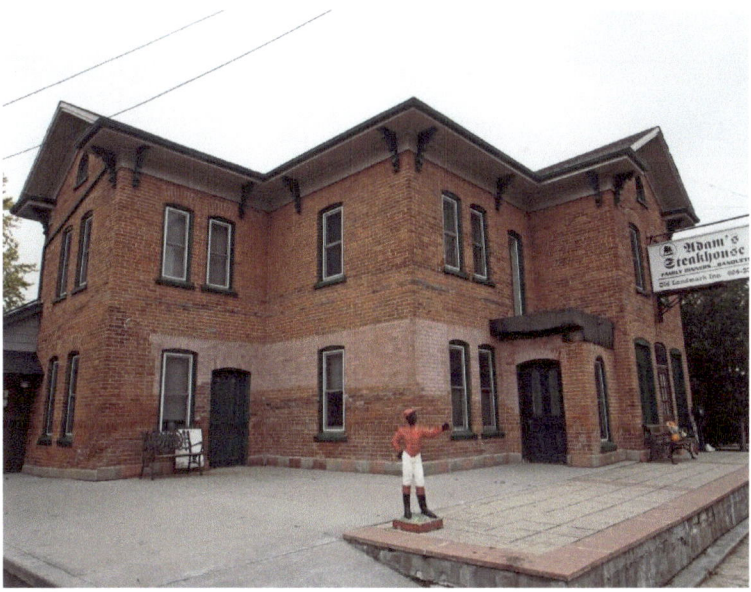

Italianate, cornice brackets – Old Landmark Inn

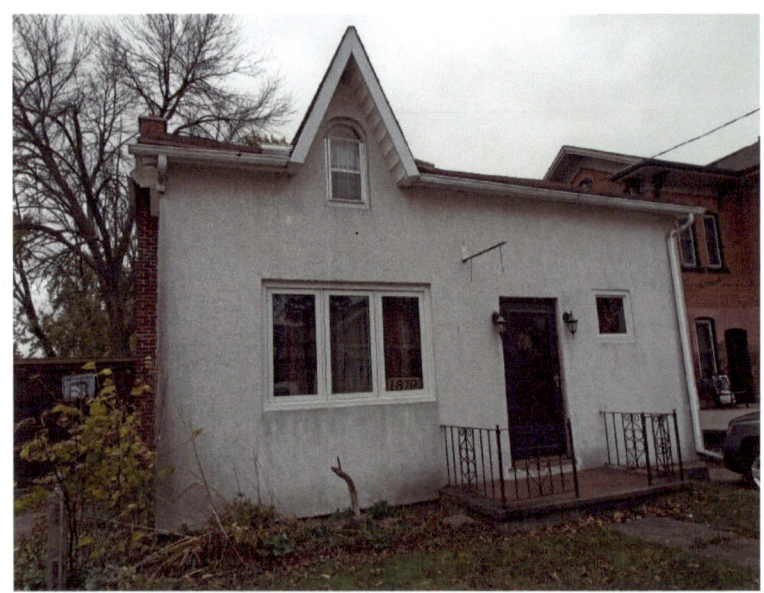

1879 Sawmill Road - Gothic cottage

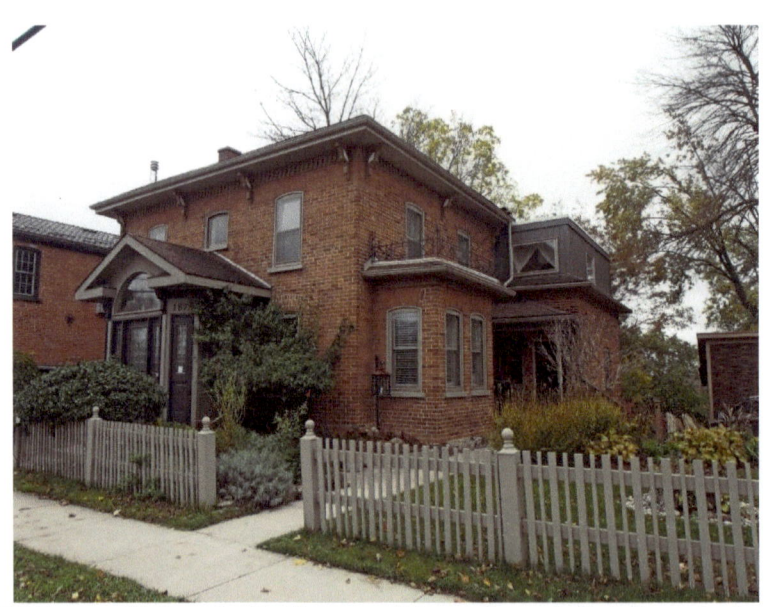

1875 Sawmill Road - Italianate, hipped roof, 2$^{nd}$ floor balcony above rectangular bay window, transom window

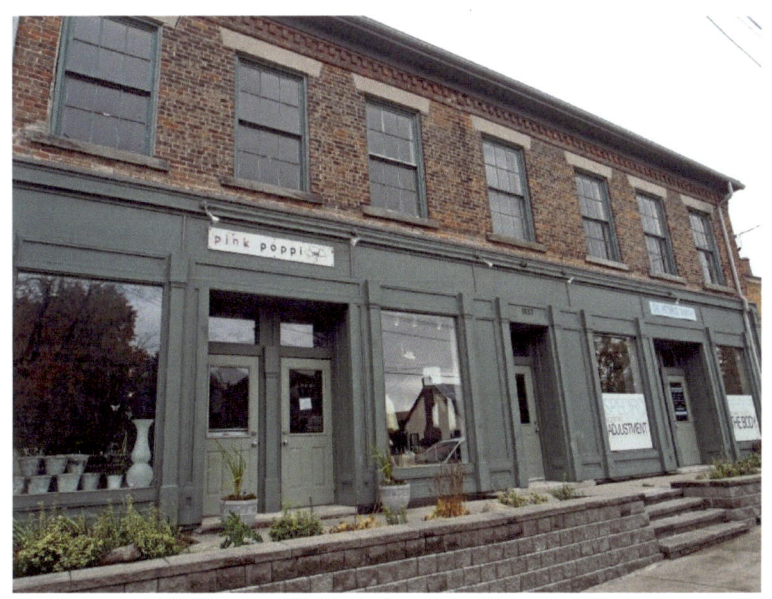

1857 Sawmill Road – dentil moulding

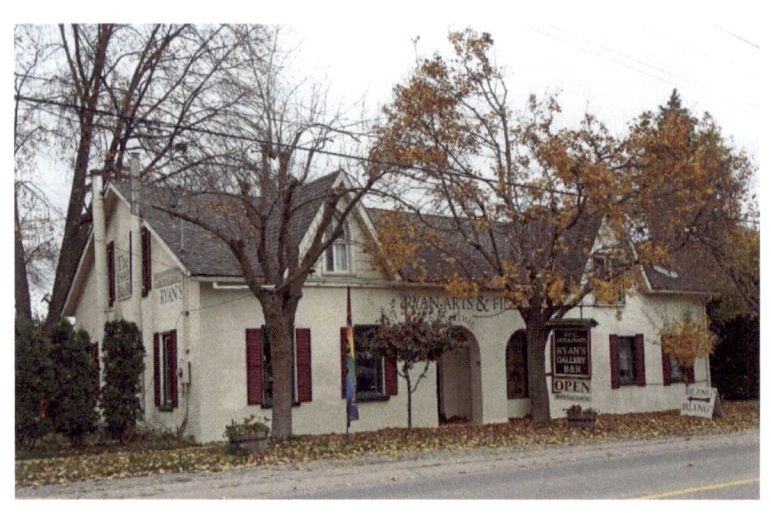

The 1842 Bed & Breakfast

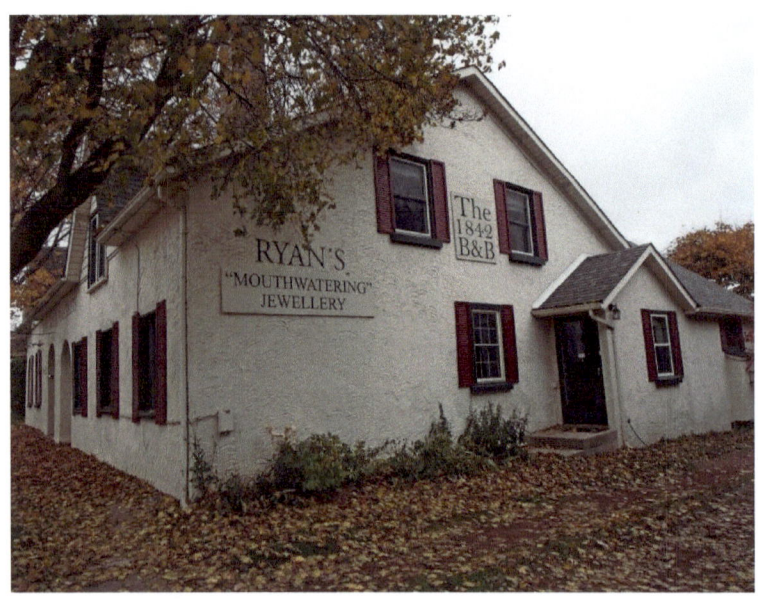

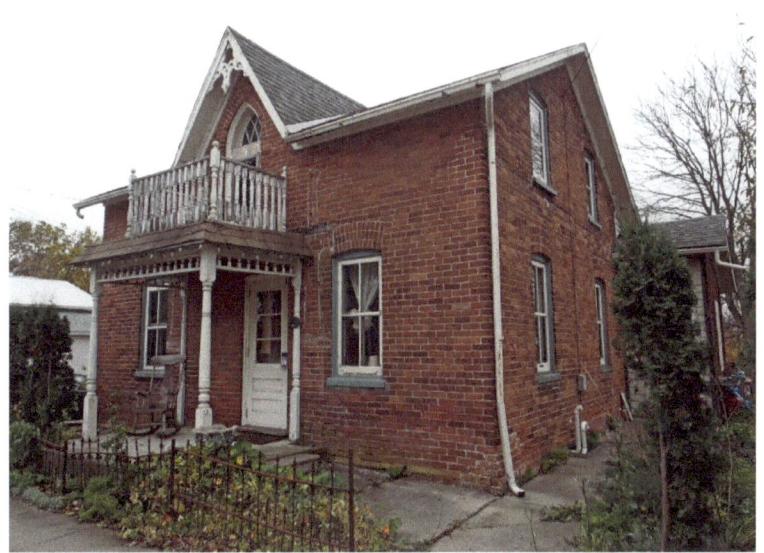

Gothic Revival, finial on gable, 2nd floor balcony

1836 Sawmill Road - Gothic Revival

1830 Sawmill Road – cobblestone architecture - Gothic 2nd floor balcony

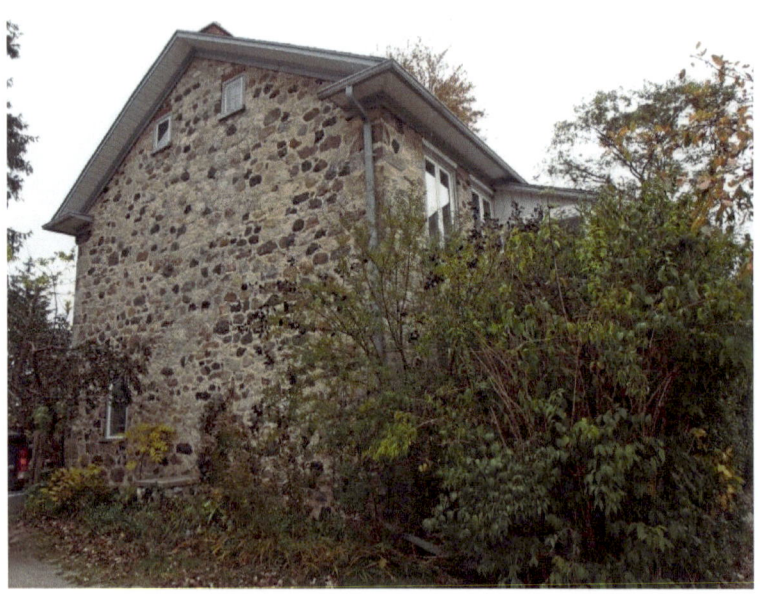

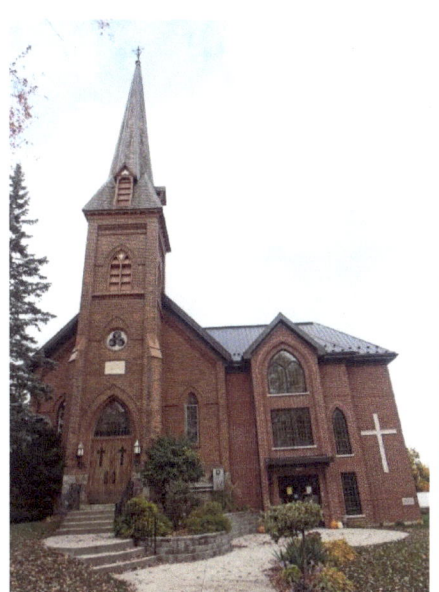

St. Matthews Evangelical
Lutheran Church A.D. 1892

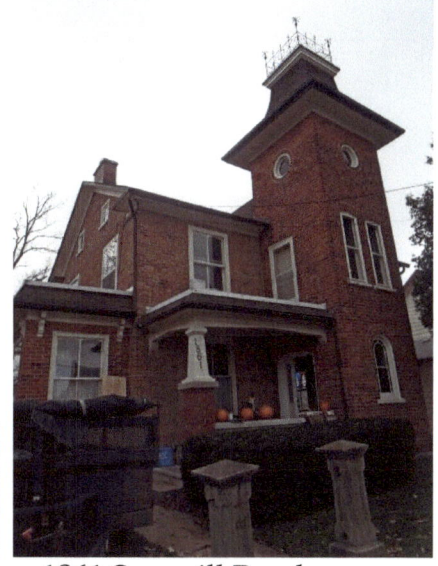

1861 Sawmill Road
3 storey tower with widow's walk and iron cresting, Cornice brackets

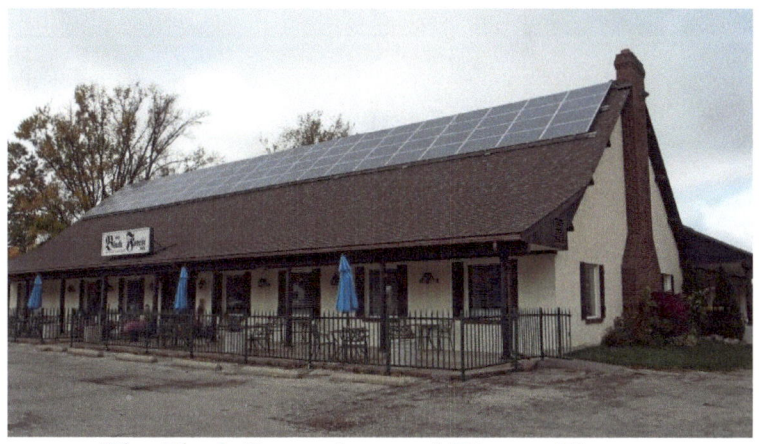

The Black Forest Inn and Dinner Theatre

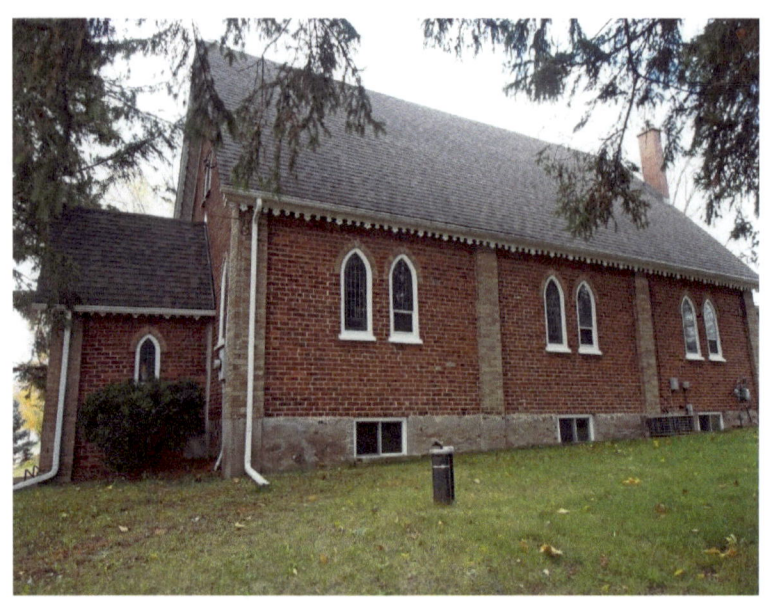

Methodist Church of Canada 1878 – lancet windows

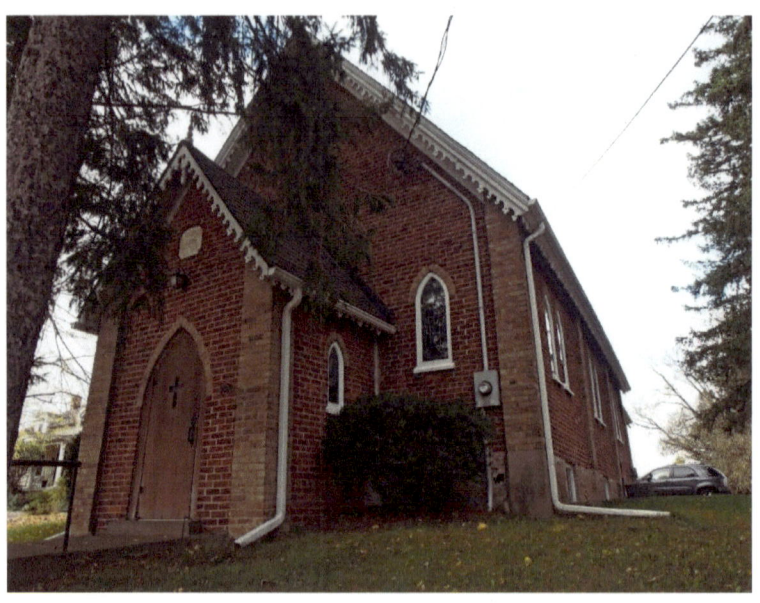

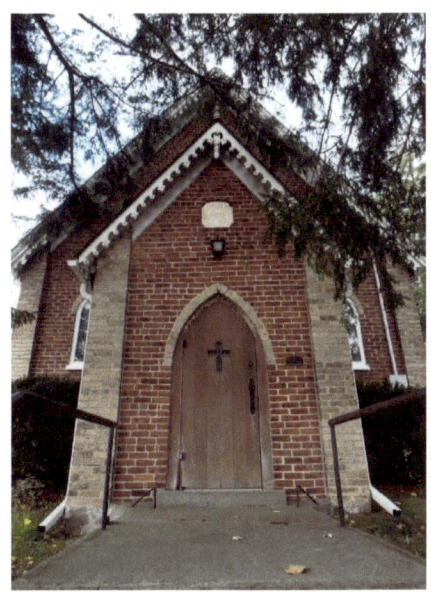

Verge board trim and finial on gable

#1030

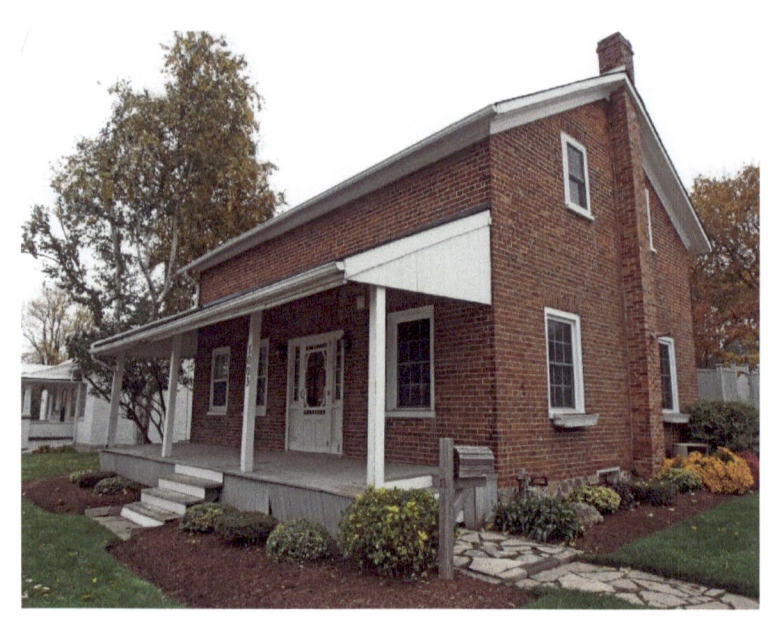

#1003

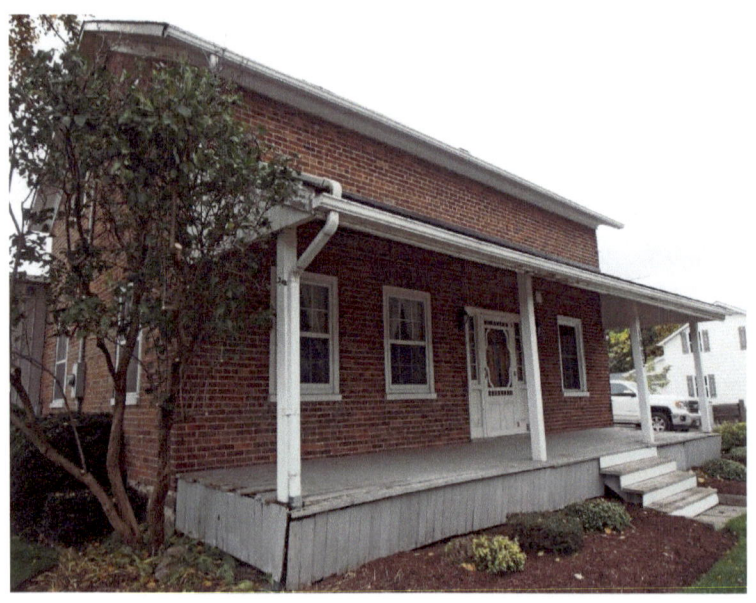

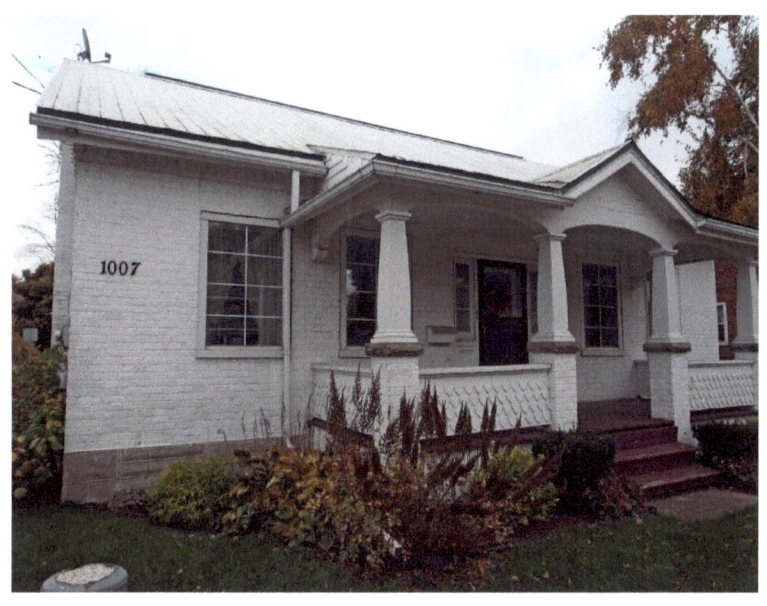

#1007 – Gothic, dentil moulding under eaves

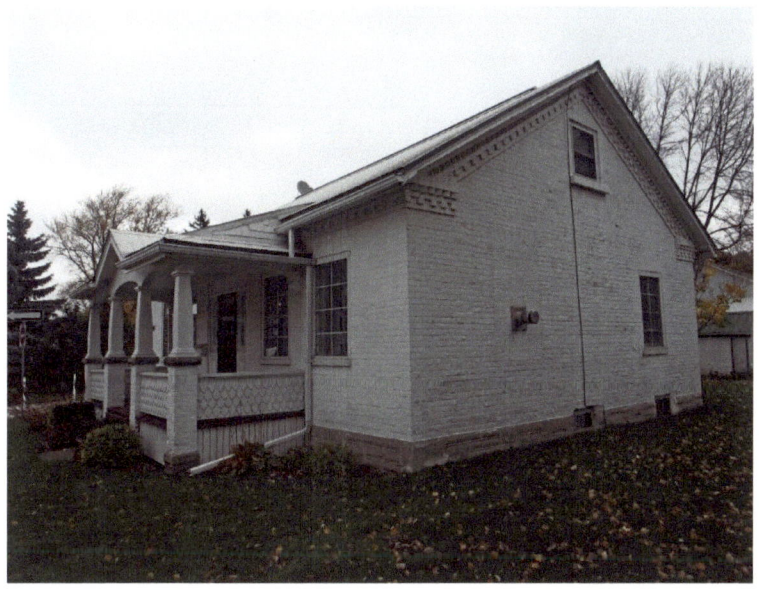

# Bloomingdale

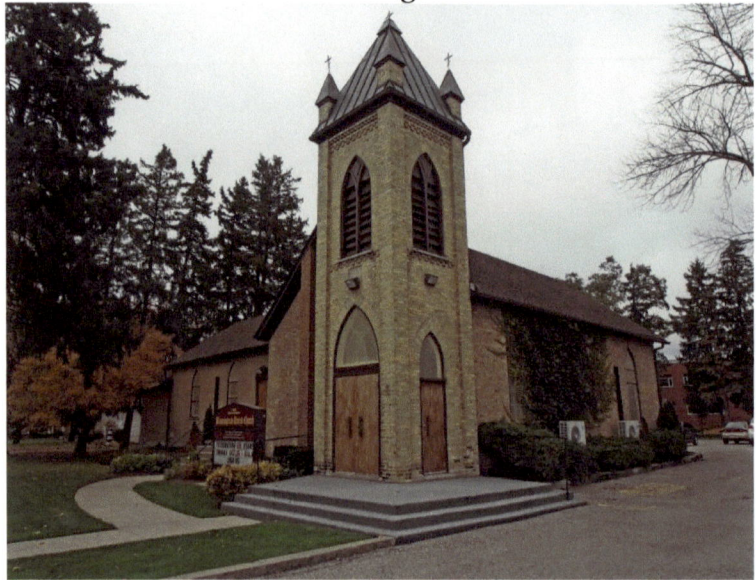

860 Sawmill Road – Bloomingdale United Church

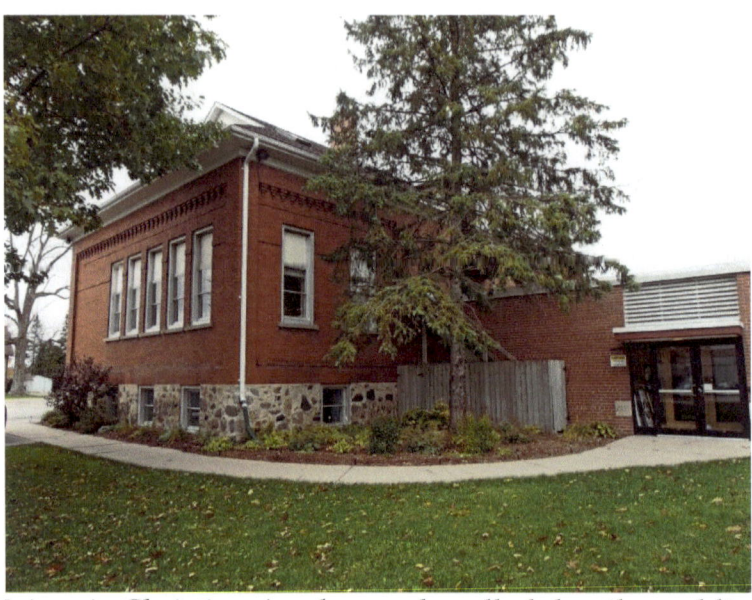

Koinonia Christian Academy – bevelled dentil moulding

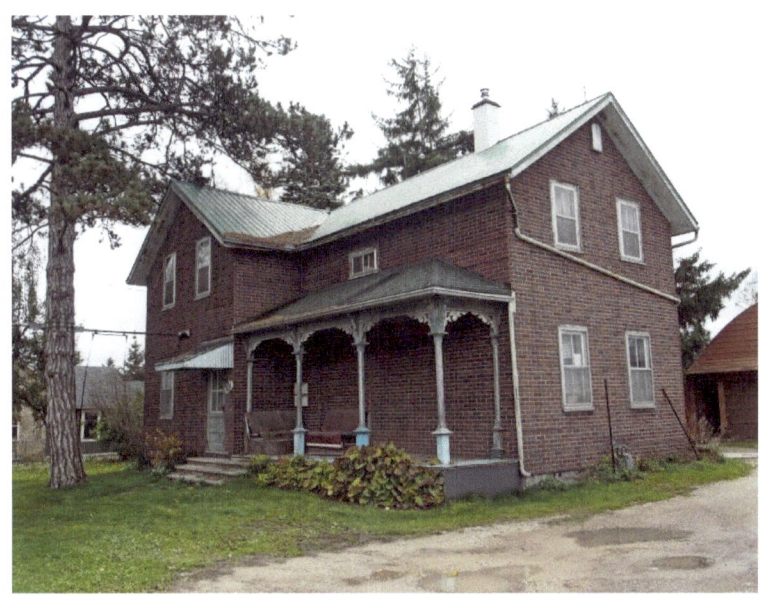

Gothic Revival

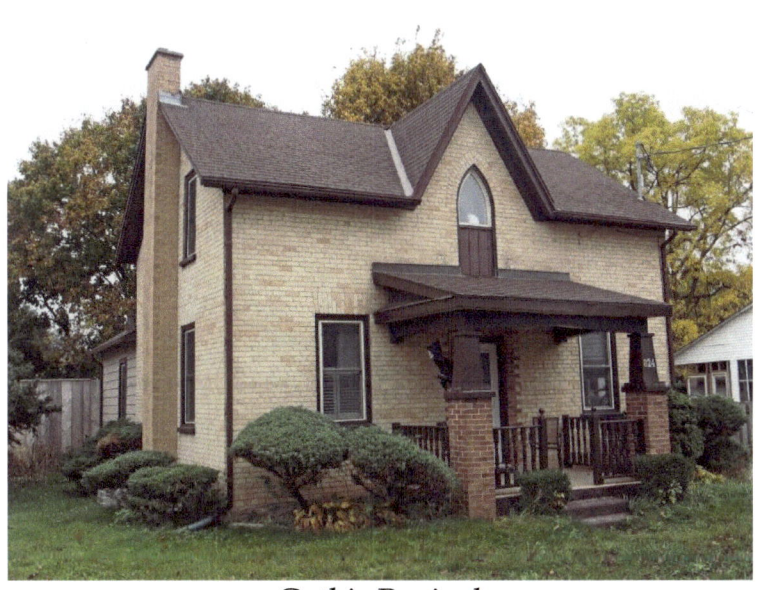

Gothic Revival

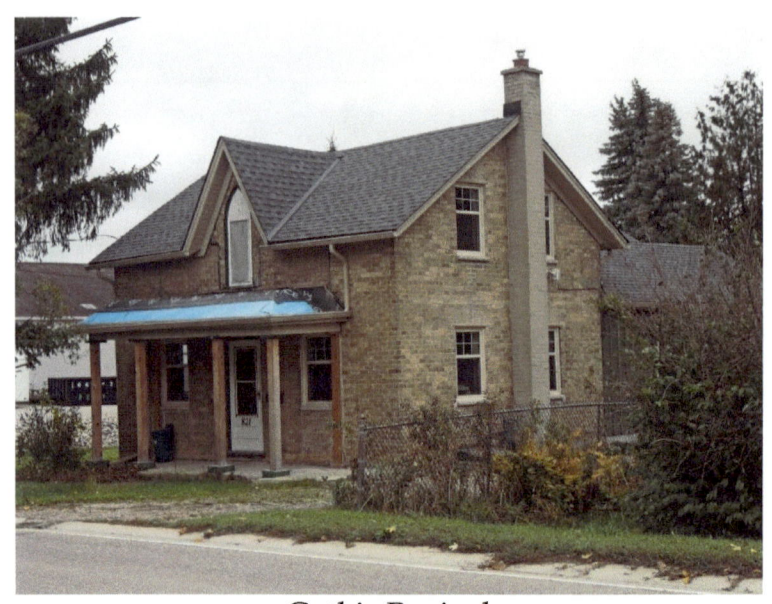

Gothic Revival

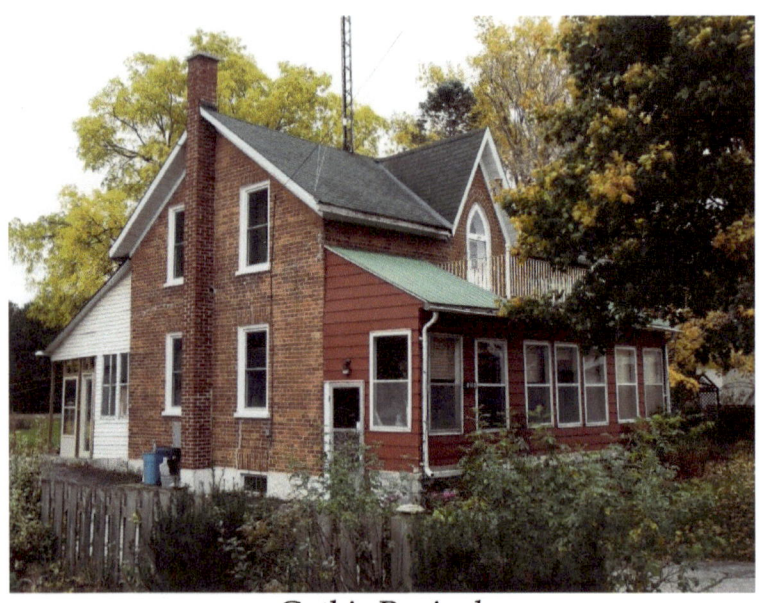

Gothic Revival

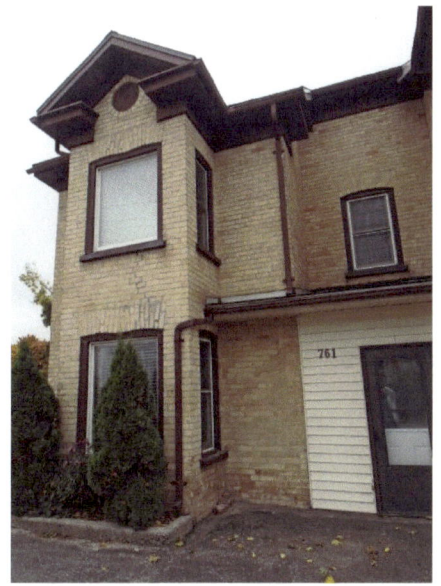

761 Sawmill Road

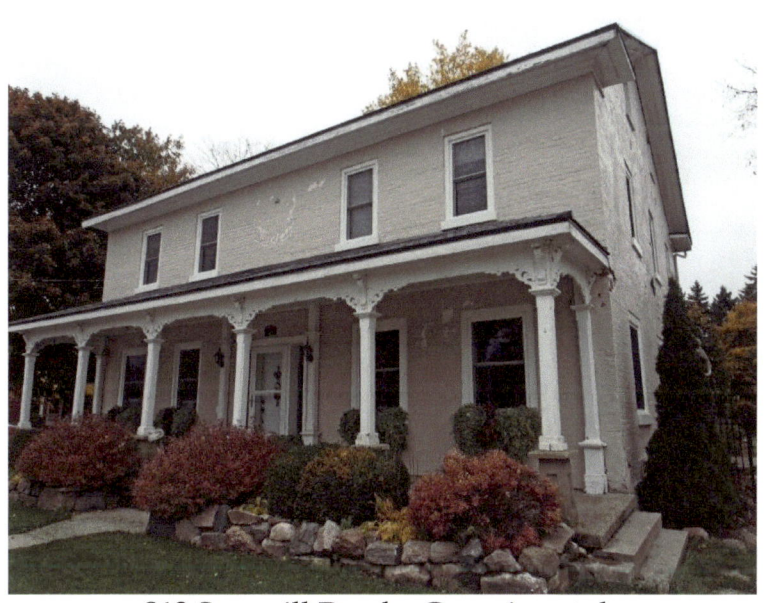

812 Sawmill Road – Georgian style

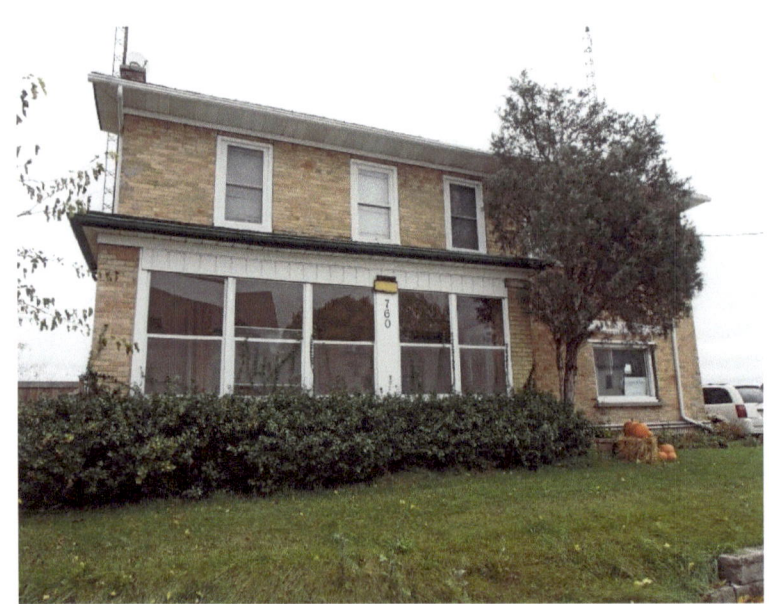

760 Sawmill Road - Italianate

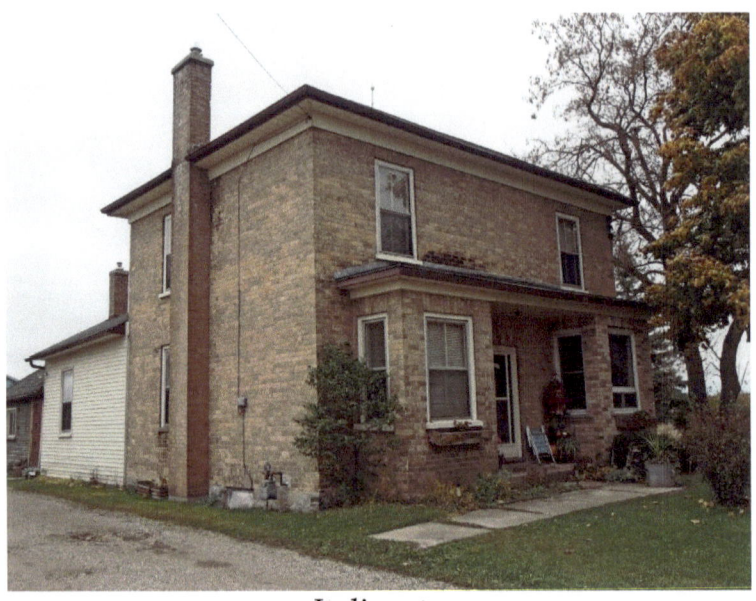

Italianate

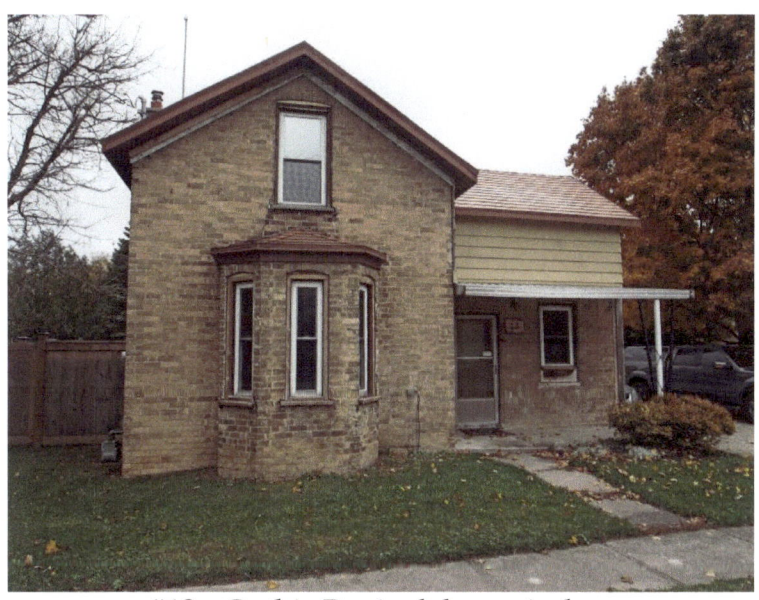

#12 - Gothic Revival, bay window

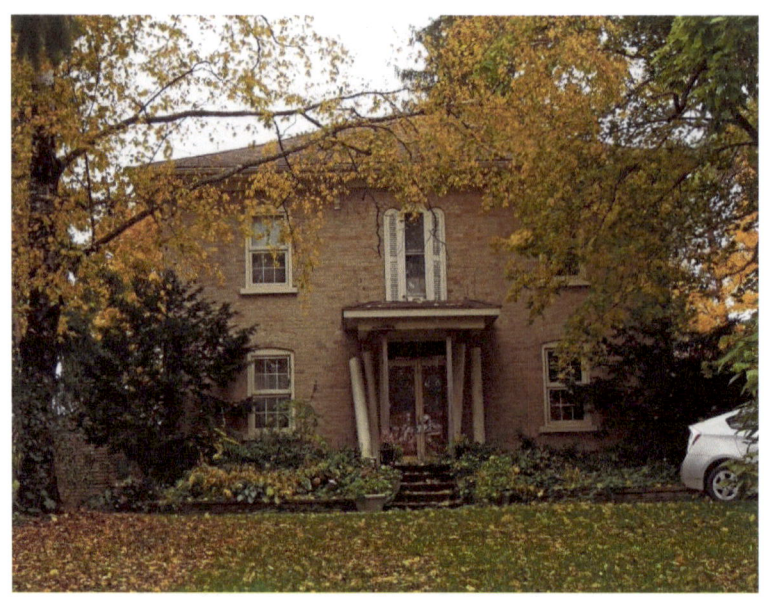

Italianate, hipped roof

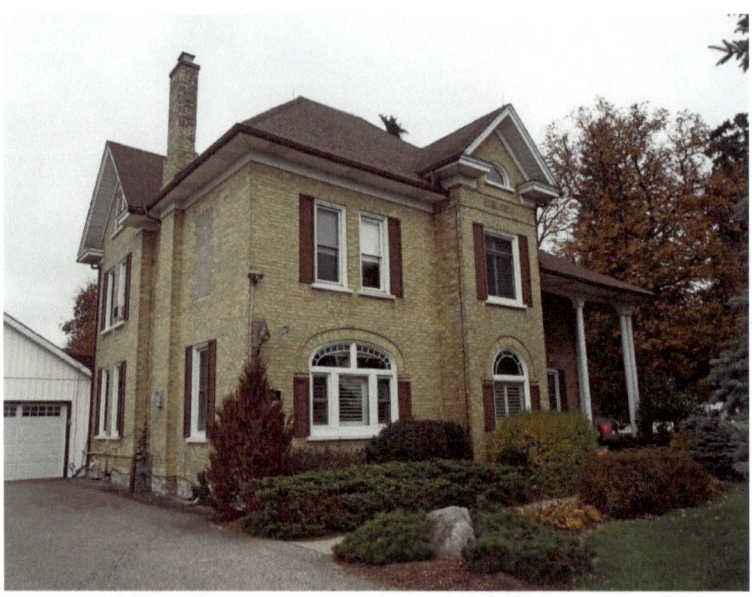

544 Sawmill Road – 2½ storey tower-like bays, cornice return on gable, Romanesque style window voussoirs

# West Montrose

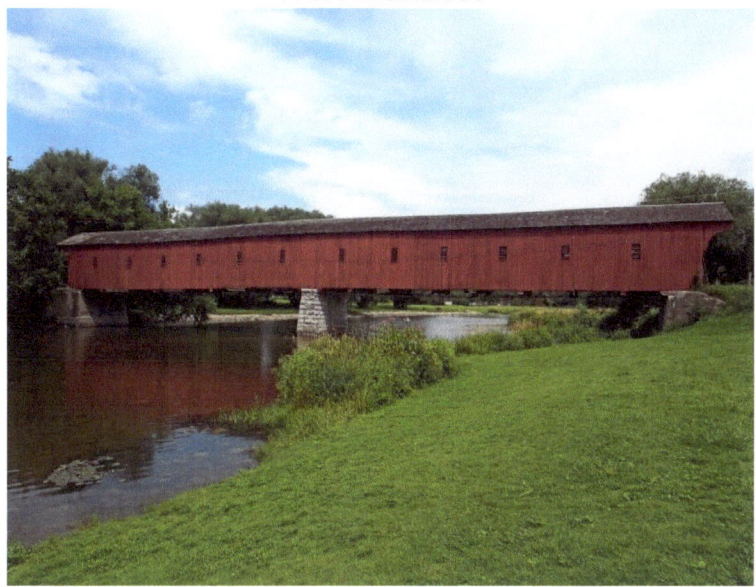

# Covered Bridge

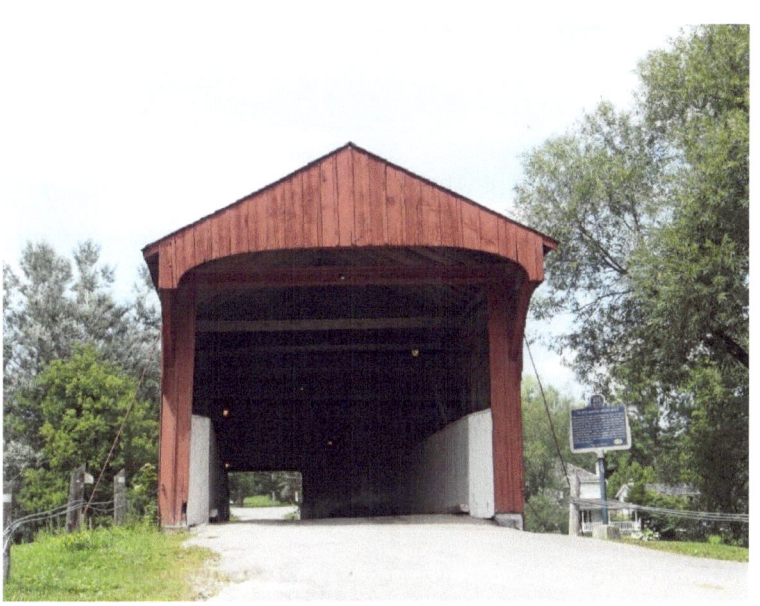

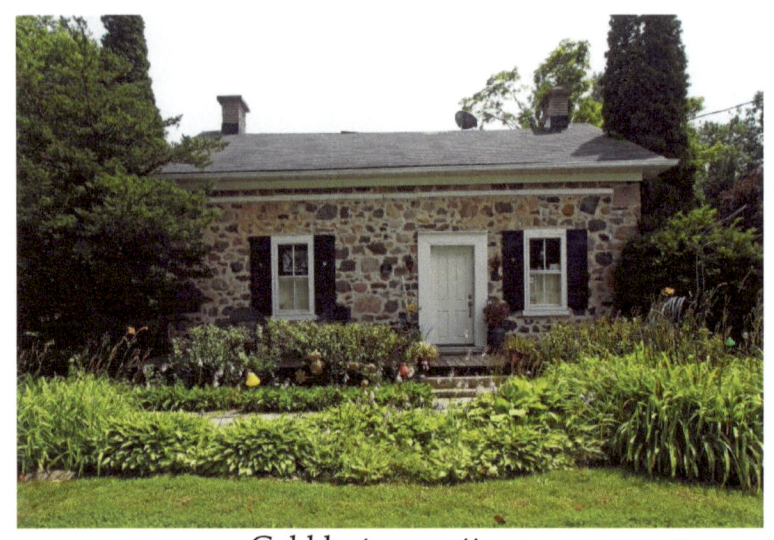

Cobblestone cottage

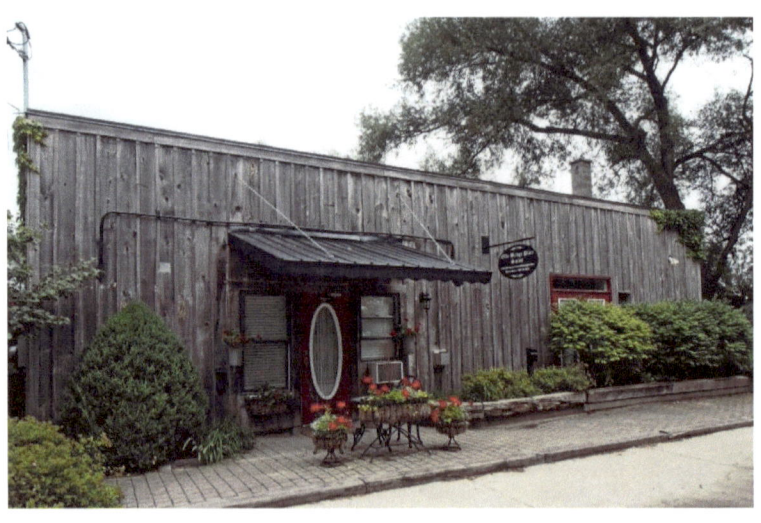

#10 – two storeys, hipped roof

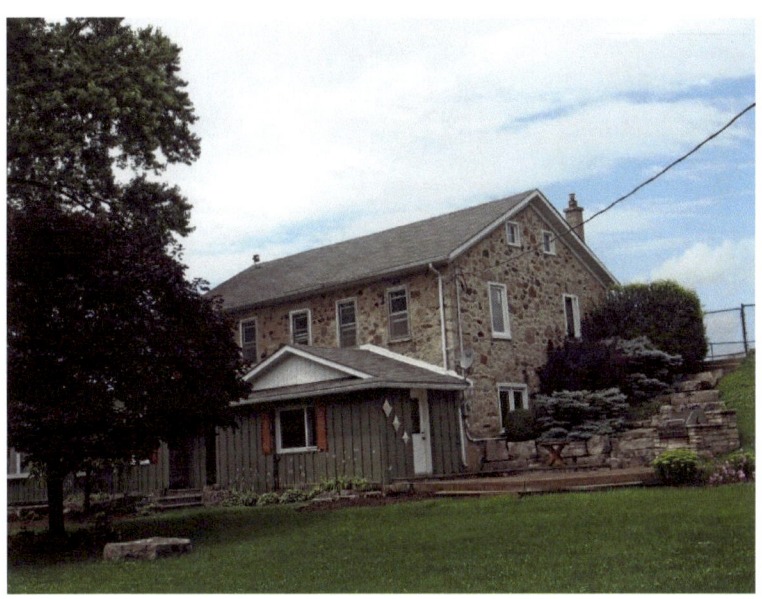

Gothic Revival - cobblestone

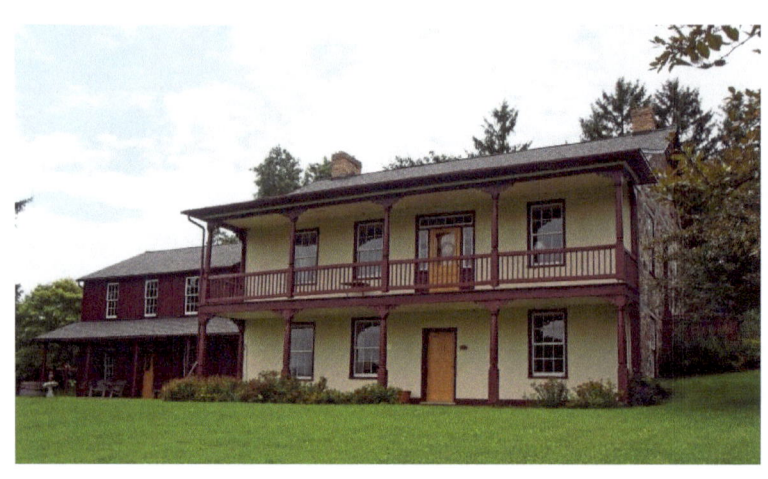

#52 - two storeys, Georgian style
1858 Heritage Building

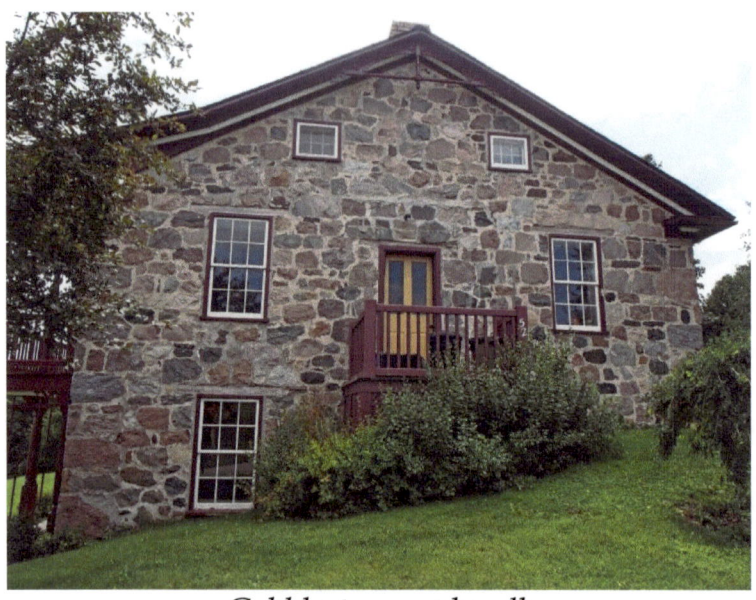

Cobblestone end wall

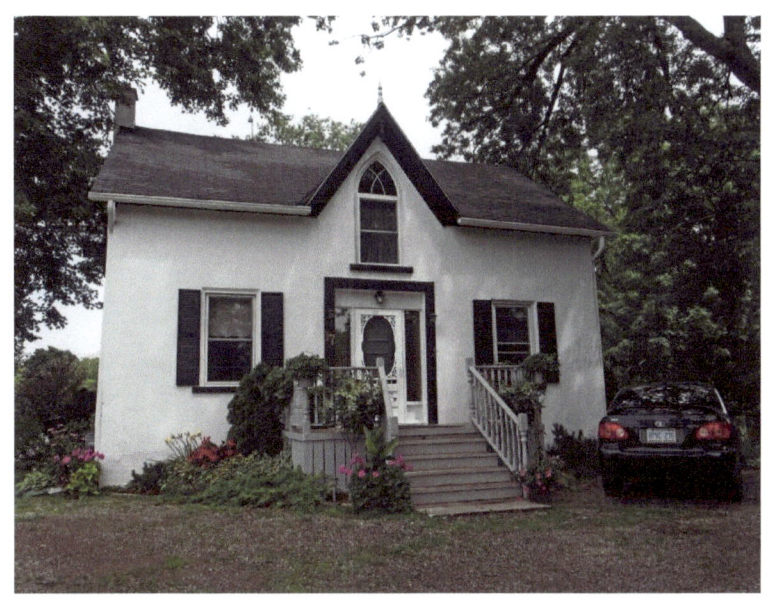

#17 - Gothic Revival

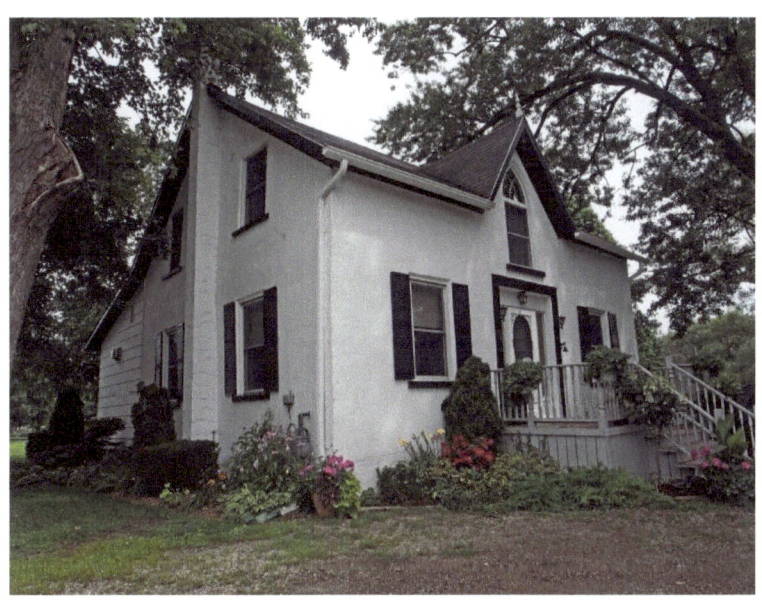

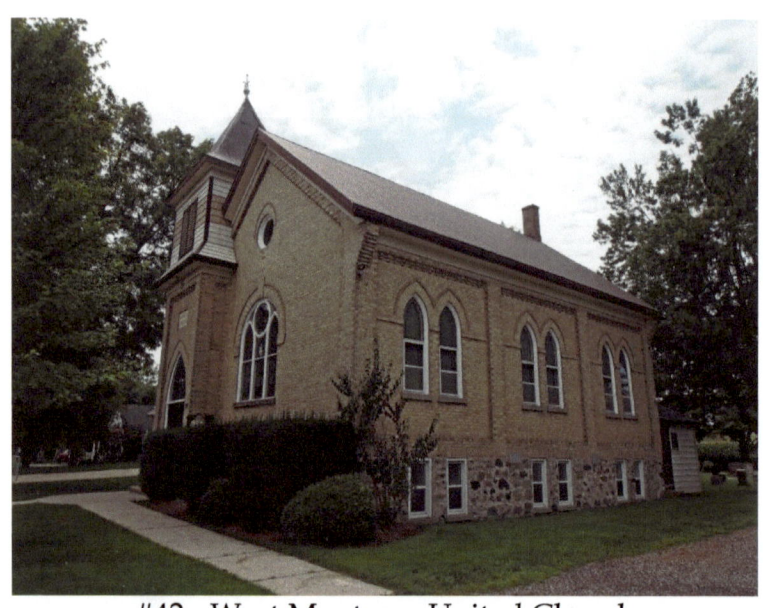

#42 - West Montrose United Church
(Former Congregation Church) 1907, lancet windows,
cobblestone basement walls, bevelled dentil moulding

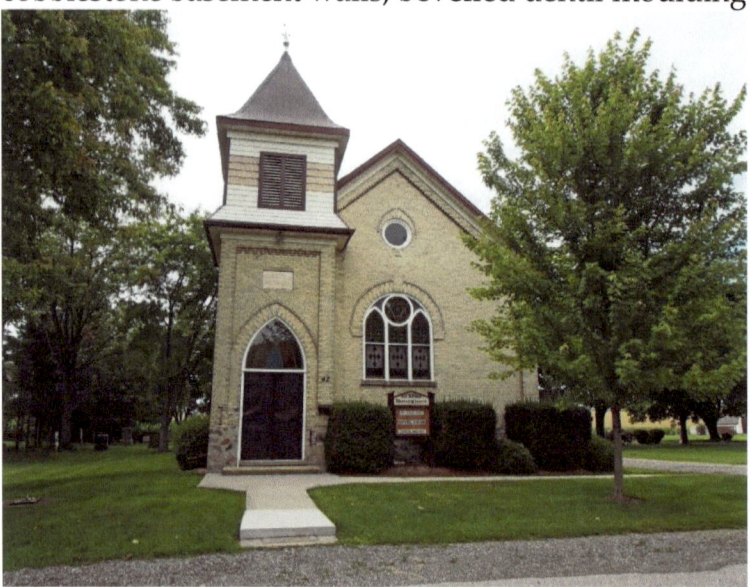

Romanesque style window voussoir with keystone

Bed and Breakfast

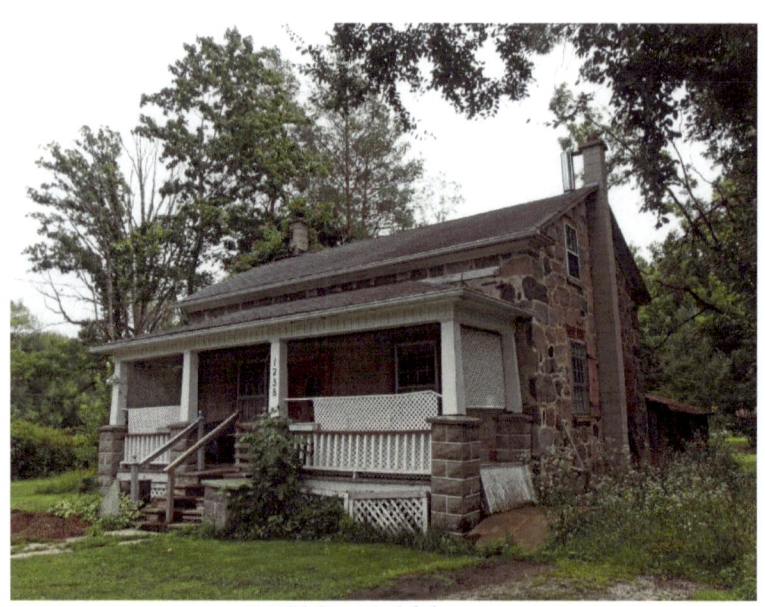

# 1238 - Cobblestone

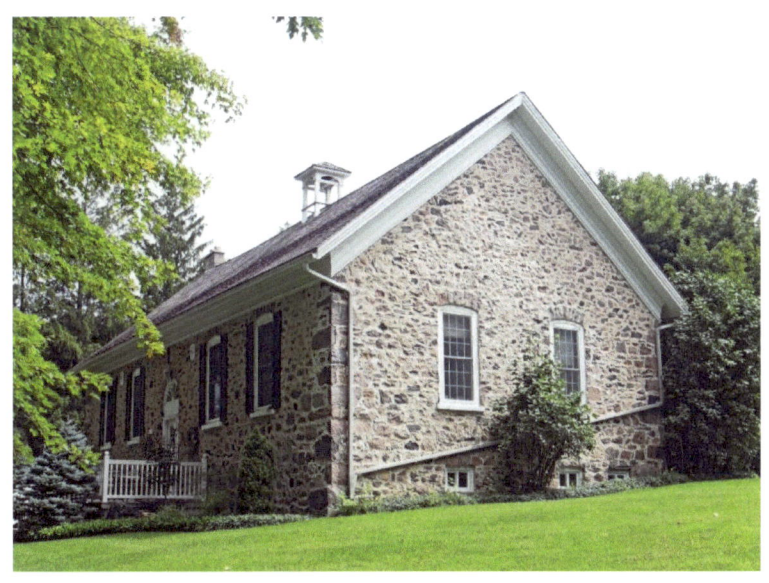

Gothic Revival - cobblestone architecture, cupola

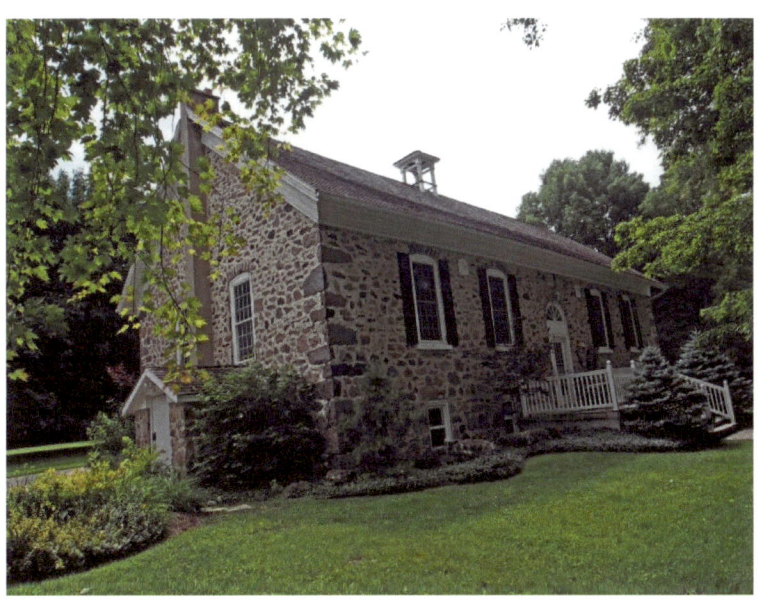

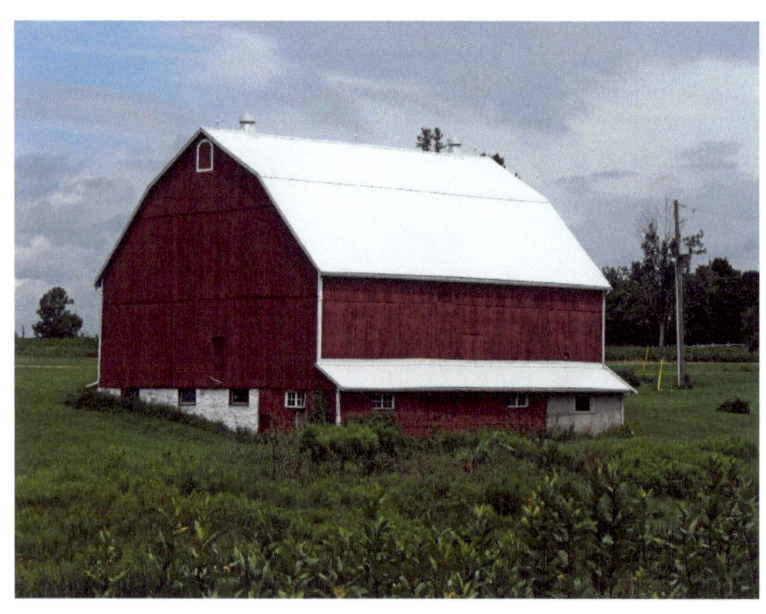

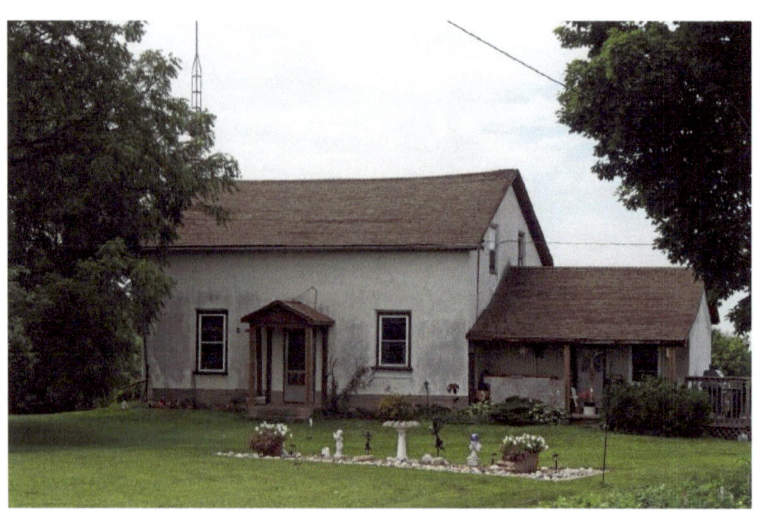

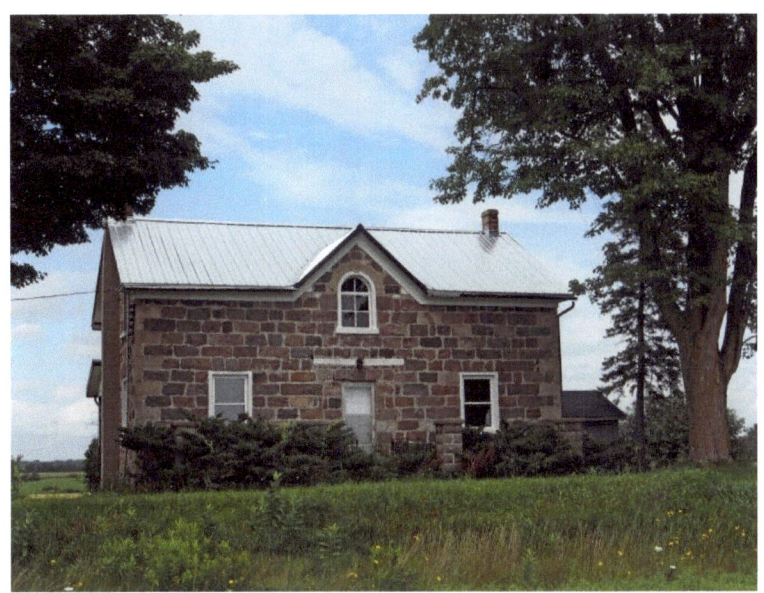

Gothic - cobblestone

Ariss

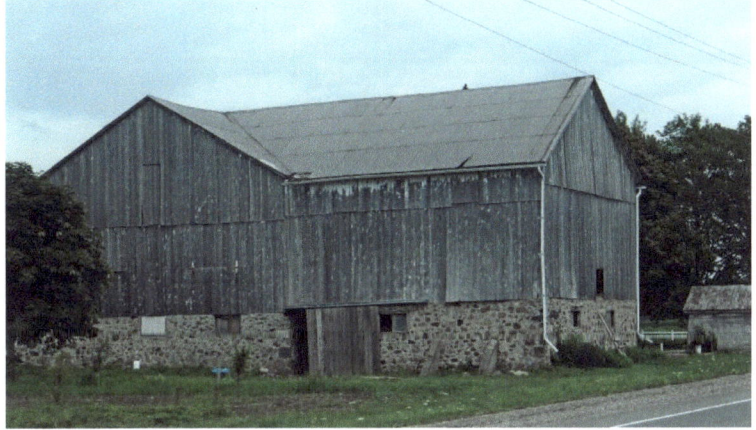

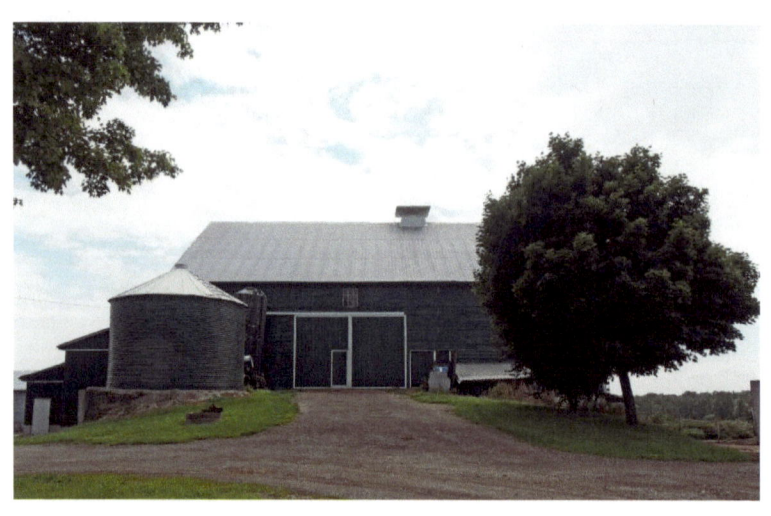

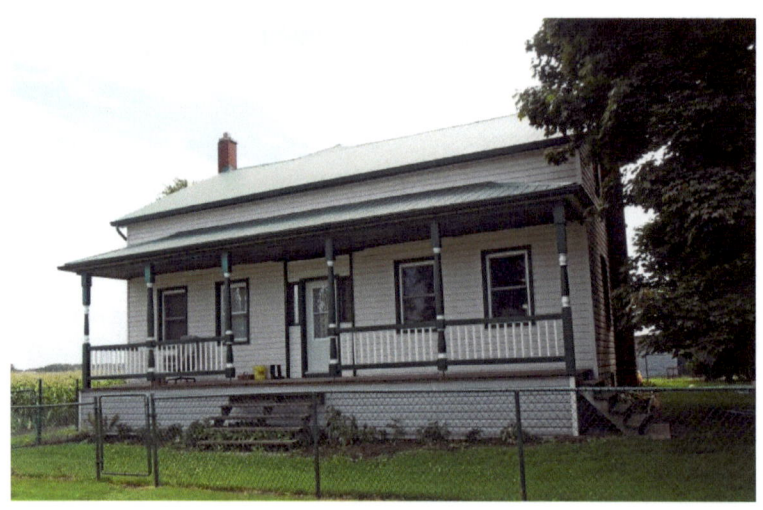

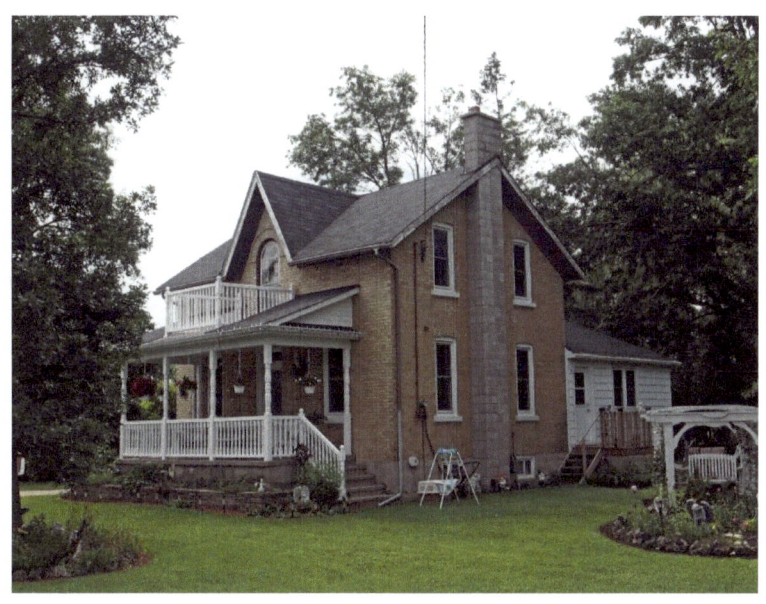

Gothic Revival, 2nd floor balcony

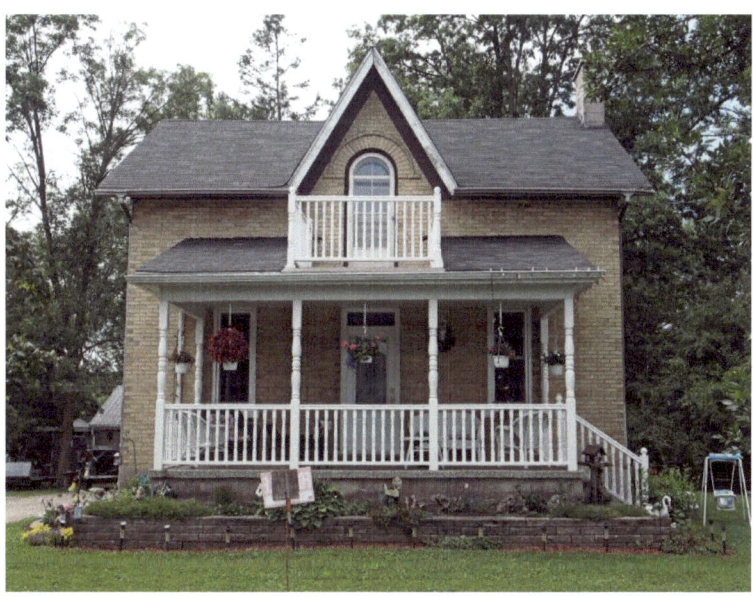

# Architectural Terms

| | |
|---|---|
| **Bay Window:** A window that projects out from a wall, in a semicircular, rectangular, or polygonal design. Used frequently in Gothic and Victorian designs.<br>Example: Conestogo, Page 10 | |
| **Brackets**: a decorative or weight-bearing structural element which forms a right angle with one side against a wall and the other under a projecting surface such as an eave or roof.<br>Example: Conestogo, Page 16 | |
| **Cobblestone architecture:** Refers to the use of cobblestones embedded in mortar as a method for erecting walls on houses and commercial buildings.<br>Example: West Montrose United Church | |
| **Cornice Return:** decorative element on the end of a gable.<br>Example: See Page 14 | |
| **Cupola:** A domed or curved roof rising from a building as a decorative element.<br><br>Example: West Montrose, see Page 42 | |
| **Dentil Moulding**: an even series of rectangles used as ornamental decoration in cornices.<br>Example: 1857 Sawmill Road, Conestogo, see Page 18 | |

| | |
|---|---|
| **Entrance:** The entrance encompasses the doorway and the inner vestibule or, in residential architecture, the covered porch. Example: see Page 9 | 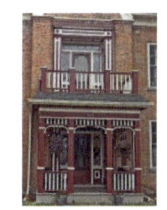 |
| **Fretwork:** interlaced decorative design resembling a bracket<br><br>Example: see Page 12 | 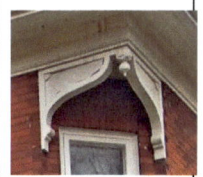 |
| **Gable**: the triangular portion of a wall between the edges of a sloping roof.<br><br>Example: 1879 Sawmill Road, see Page 18 |  |
| **Hipped Roof**: a roof where all sides slope downwards to the walls with no gables. Example: West Montrose, see Page 36 |  |
| **Iron Cresting**: A decorative ornament along the top of a roof. Iron cresting was popular in the Baroque era and also in Italianate, Victorian, Second Empire and Queen Anne styles of architecture.<br>Example: 1861 Sawmill Road, see Page 36 | 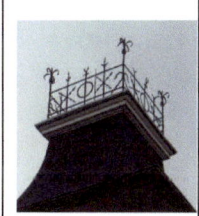 |

| | |
|---|---|
| **Keystones and Voussoirs**: a voussoir is a wedge-shaped element used in building an arch. A keystone is the central stone that locks all the stones into position, allowing the arch to bear weight. A keystone is often enlarged and embellished.<br>Example: West Montrose United Church, Pg.39 | |
| **Lancet Window**: a tall, narrow window with a pointed arch at its top.<br><br>Example: West Montrose United Church | |
| **Pediment**: a triangular section above the horizontal structure (entablature), typically supported by columns. The inside of the triangle is called the tympanum.<br>Example: 1880 Sawmill Road, see Page 15 | |
| **Quoin**: masonry blocks at the corner of a wall, often a decorative feature, usually larger or of a different colour than the rest of the wall.<br><br>Example: see Page 10 | |
| **Transom Window:** the light above the doorway, also called a fanlight.<br><br>Example: 1875 Sawmill Road, see Page 17 | |
| **Verge board and Finial**: also called bargeboards – hang from the projecting end of a roof and are often elaborately carved and ornamented. **Finial:** ornament added to the top of a gable, pinnacle, canopy or spire – a Gothic element. Example: Methodist Church of Canada | |

# Building Styles

| | |
|---|---|
| Edwardian, 1900-1930 – This style bridges the ornate and elaborate styles of the Victorian era and the simplified styles of the 20th century. Balanced facades, simple roof lines, dormer windows, large front porches, and smooth brick surfaces are its characteristics. Example: see Page 12 | |
| Georgian, before 1860 – This style began with the British King Georges in the 18th century. These buildings have balanced facades around a central door, medium-pitched gable roofs, and small paned windows. Example: 812 Sawmill Road, Bloomingdale, see Page 30 | |
| Gothic Revival, 1830-1890 – These decorative buildings have sharply-pitched gables with highly detailed verge boards, pointed-arch window openings, and dichromatic brickwork. It is a common style in Ontario. Example: 1912 Sawmill Road, see Page 11 | |
| Italianate, 1850-1900 – It has wide-bracketed eaves, belvederes, wrap-around verandahs. Example: 1875 Sawmill Road, see Page 17 | |
| Romanesque Revival, 1880-1910 – This style hearkens back to medieval architecture of the 11th and 12th centuries with a heavy appearance, blocky towers and rounded arches. Example: see Page 14 | |

www.ingramcontent.com/pod-product-compliance
Lightning Source LLC
Chambersburg PA
CBHW040920180526
45159CB00002BA/547